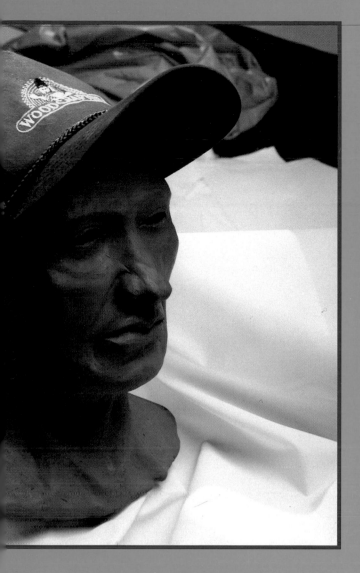

From Clay to Wood

Steps to Carving Realistic Faces

Terry Kramer

Text written with
& photography by
Douglas Congdon-Martin

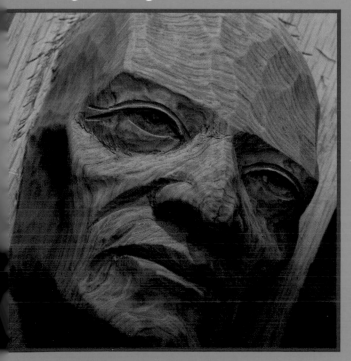

Schiffer Publishing Ltd

77 Lower Valley Road, Atglen, PA 19310

Dedication

I dedicate this book to all my students, who, collectively, have been my best teacher.

Printed in China
ISBN: 0-88740-714-5

Library of Congress Cataloging-in-Publication Data

Kramer, Terry.
 From clay to wood : steps to crving realistic faces / Terry Kramer ; text written with & photography by Douglas Congdon-Martin.
 p. cm.
 ISBN 0-88740-714-5 (soft)
 1. Wood-carving--Technique. 2. Modeling. 3. Face in art.
I. Congdon-Martin, Douglas. II. Title.
TT199.7.K73 1995
731'.82--dc20 94-49423
 CIP

CONTENTS

Published by Schiffer Publishing Ltd.
77 Lower Valley Road
Atglen, PA 19310
Please write for a free catalog.
This book may be purchased from the publisher.
Please include $2.95 postage.
Try your bookstore first.

We are interested in hearing from authors
with book ideas on related topics.

Introduction

The basic goal of this book is to improve one's ability to carve or sculpt realistic human faces and to assist in developing one's overall carving skill.

Gary Faigin, in his book *The Artist's Complete Guide to Facial Expressions*, writes

There is no landscape that we know as well as the human face. The twenty-five odd square inches containing the features is the most intimately scrutinized piece of territory in existence, examined constantly, and carefully, with far more than an intellectual interest. Every detail of the nose, eyes, and mouth, every regularity in proportion, every variation from one individual to the next, are matters about which we are all authorities. We've come to know the face so well because it's so important to us; in fact, it's the center of our entire emotional life. From birth to death, the face links us to friends, to family, to everyone meaningful to us. Few things are capable of moving us as deeply as the face of a loved one; nothing interests us as much as looking at that same face, in all its moods, in its evolution over time.

And yet when the time comes to carve the face, most carvers will agree that the face is the most difficult of all subject matter. The fact that we are such authorities on faces is what makes them so difficult to carve. If a face carving is not executed to perfection, both the carver and the audience will recognize this fact. A carver cannot fake a good face.

It seems a strange dilemma that, having spent so much time looking at faces and having become such authorities on them, we should still have difficulty carving good faces. Apparently the way that we have looked at faces is not the way we need to look at them if we are going to carve them. This book is about learning a different way to look at faces.

In my teaching and association with hundreds of fellow carvers and sculptors I have meet a number of very talented persons who were very good artists within a specific area. Very few of these were able to carve satisfactory realistic faces. I have also met a much smaller number of carvers who were able to produce very good realistic faces. For the most part, I found that they were able to carve any subject matter well. I don't believe this is a coinci-dence. Any one who learns to master the human face, will be able to carve any subject matter well. The skills and techniques required to produce realistic faces are so basic and exacting that once mastered, they will carry over into all of your other carving and will improve your overall carving skills.

Because most carvers think that carving realistic faces is one of the most difficult carving tasks, once you have mastered the ability to carve realistic faces it will do much to improve your self confidence and self esteem. In addition, the positive attention that you will get from others who will recognize your skills will further enhance your confidence which will lead to further improvement. Since you are constantly surrounded by faces which you can observe and learn from, your powers of observation will increase.

If we are so familiar with faces and studied them so much and still can not carve them, then what must we do? The answer is that we must learn to see faces in a way that is different from the way we have viewed faces for all our lives.

Having taught classes on realistic face carving for over six years, I have come to the realization that my principle task is to get students to see faces differently than they have been viewing them all their lives. As a matter of fact it is my task to change their way of visualizing the world. If this can be accomplished, and it can be, not only will it affect the students ability to carve faces but to carve anything. Having discovered this process, their lives, as well as their art, will be much enhanced by their new found ability.

I firmly believe that if a person takes my class or follows the exercises in this book and never carves another face, whatever they have been carving will improve and the overall quality of their lives will improve. THE WORLD WILL BE A FAR MORE INTERESTING PLACE TO LOOK AT.

Setting the mental tone for improvement

Carving, like most endeavors, starts with a proper mental attitude. You need to believe that you

are going to improve and be able to accomplish much more in the future than you are capable of at present. How many times have you heard a carver play down their work and the compliments it receives. "Oh, I'm not very good." or "I just started. You should see so-and-so's work; they're much better". This attitude does not support positive growth. How are you to improve if you put yourself and your work down. If you can't say anything else simply say,"Thank you, I enjoy what I do". Better yet, say, "Thank you, I enjoy what I do and wait till you see what I'll be able to do next year.

To be a good carver, you must build confidence in yourself and those around you. With the proper attitude you will not disappoint them or yourself.

Having a goal

In this day and age it seems funny to have to talk about the importance of a carving goal. Everyone knows that goals are guideposts that govern our activities and accomplishments, but you would be surprised at how many carvers have no carving goals other than to do a certain carving. Thank heaven for today's juried shows that many carvers are entering. They have given carvers goals, the goal to improve and win a ribbon, to move up a class, to do a best of show carving, or win the people's choice award. It has been my experience that any carving club that conducts juried shows and gives awards for carving ability is directly responsible for the dramatic improvement of its carvers. The ribbon may not be important, but the desire to win is. This gives the mind a direction and once directed the mind will govern perception and activity towards the achievement of the goal. Without carving goals you will simply drift around, like a boat with out a rudder or a destination. It is possible to carve for twenty years and show little improvement, and that's okay if its your goal. But I don't know many carvers who would not like to improve what they are doing if they thought they could.

You need to be clear with yourself about what your goal is. It may be as simple as finding an enjoyable way to spend your time or as ambitious as becoming a world champion bird carver. It is a pretty safe bet that, if your goal is to simply enjoy yourself, you will not be a world class bird carver. If your goal is to be a world class champion you may not make it, but the chances are very much greater that you will come closer than the person whose goal is to enjoy himself. In the process you will become a much better carver and you will probably enjoy carving more.

You will get much more out of this book if you write down a goal to be achieved by using this book. The clearer your goal the greater the possibility there is that you will achieve your goal. So do your mind

a favor and tell it what you expect it to help you accomplish. The clearer and simpler you state your goals the better. A goal should be stated as a desired outcome and it should be able to be measured, to determine if it has been accomplished. Goals should also be stated in a positive manner.

A good goal for this book could be: "My goal is to go through the exercises in this book and definitely improve my face carving skills to a degree that I and others who view my carvings will recognize the improvement."

This book has been developed from a face carving seminar that I have been teaching for the last six years. The class lasts 5 days and covers about 35 hours of class time. It originally lasted 4 days, but that was not enough time to teach what needed to be learned to improve one's face carving skills. One of my primary goals has always been to improve my teaching skills. It appears that my goal is being met as my students have been getting progressively better and better with each class.

Every now and then, I stop and ask, what now needs to be done to insure that students continue to improve? What have I been doing that is helping them to improve?. After all these years the answer seems very clear. I am teaching them to see faces differently than they have seen them before. More importantly I am teaching them a new way to see.

Seeing with a Carver's Eyes

The normal way of seeing uses our normal, well-developed seeing skills. These skills have been developed for dealing efficiently with the world we live in and operate something like this. As we mature, we form visual symbols to represent the world around us. We have symbols for all objects known to us. We have symbols for dogs, cats, birds, trees, cars, as well as for noses, ears, mouths, eyes and so on. If you don't believe this draw an eye, or a mouth or a tree. Unless you have had art training your picture will look much like a picture drawn by a second or third grade school child. It will look like this because it was before you were in primary school that most of your basic symbols developed and they haven't changed as you have grown older. These symbols prevent you from seeing and representing what you see, whether a drawing or carving. They will continue to do so until you do something to change the way you see. This way of seeing is dominated by the left hemisphere of our brain. This hemisphere, dominant in most persons, is logical and analytical, and perceives in ways that seem to interfere with artistic endeavors.

The new way to see is the way that artists see. It is seeing the actual object rather than the symbolized object. It is seeing what you are actually representing rather than your symbol. This activity is

dominated by the right hemisphere of your brain. This hemisphere is responsible for our creative artistic activity. There is a very informative book written on this subject titled *Drawing on the Right Side of the Brain*, by Betty Edwards. I highly recommend this book to all my students and to you.

When looking a face or object, there are three major aspects to be considered. The first is overall size or mass or shape. The second is the surface planes that break the mass up into surface areas. The third is the details that define surface features. In modeling a head from clay, you first form the mass, then you model the surface planes such as the temporal planes, the planes of the forehead, planes of the cheeks and so on. Once this is accomplished, you add the surface features. The most difficult portion of this operation is the development of the surface planes They are hidden beneath the surface features and obscured. In addition our dominate left brain has little use for these planes and tends to ignore them. As a result a carver will have the most difficulty with these intermediate planes and tend to omit or execute them poorly. But it is these planes that form the foundation of the surface features and if they are not properly executed or omitted the surface features will not look right. In addition each feature has its own mass, intermediate planes and surface features.

This book includes activities that are employed in the seminar to teach the student to become familiar with the mass and basic proportions of the face, the intermediate planes of the head and features, as well as surface features. It is important to master all of this information.

The activities in this carving book that have been taken from my face carving seminar are designed to give you a new more useful way of looking at faces.

Armed with this knowledge about how we see and being a woodcarving teacher with an extensive teaching background, I have some thoughts on wood carving classes in general. I believe that there are many classes that do not promote a lot skill development. In these classes the students are presented with a project that is to be accomplished. Presented with a sawed out blank or a spindle carved roughout, the students all work on the project and the instructor comes around and keeps the carvers from getting into too much trouble, making sure that each student goes home with a fairly nice carving. In short the student supplies the tools and makes the cuts as directed, using the teacher's brains to guide them. At the end of the class the student goes home and takes their tools and the finished carving home, but they leave the teacher's brains behind.

I think that it's important in a class to produce a good carving and it important to have a good time, but it's more important to take the brains home with you. So that you will need a teacher less and less in the future and what you learned in the class will be used in the other carving you will be doing. In all my classes and in this book my first objective is to help you become a better carver. Everything that is done in class is done because the particular activity has shown that it promotes learning.

In class we make extensive use of clay. Clay is used for several reasons, but mainly because clay is a much better learning medium than wood. Clay is very fast to work in. You can model or carve in clay over ten times as fast as you can use wood. You can correct mistakes. You can experiment in clay. You can both model and carve in clay. You can directly use your fingers and hands as tools, thus learning through touch as well as vision. You can use both hands, thus activating both hemispheres of the brain. Besides, working with clay is fun. I have never had a student who did not enjoy working with clay once they got adjusted to it and this does not take very long.

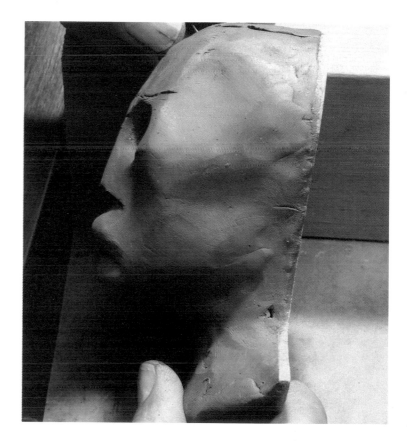

Tools & Light

For any carving project, the type and condition of the carver's tools and the type of light in which the carver works is important, particularly when one is carving a realistic face. Light is one of your most valuable tools. It is impossible to carve good faces, let alone good realistic faces, when a carver works with poor carving light. It is important that you read this section on tools and light, paying special attention to the section on light, before you begin your carving.

Tools

A large collection of fancy tools is not needed for carving faces. I have been carving faces for twenty years, and as you will see from the pictures in this book, my personal tools are not very fancy nor expensive. What I have discovered, over years of trial and error, is that particular cuts are best made with certain tools. When carving, I select the tool that has proven best for a specific cut and use that tool. When carving a face, I use an average of about twenty different tools per face. If you plan to carve a lot of faces, I suggest you try to match the tools I use in this book.

Because some of the tools I use are "homemade", you might not have the same tool in your tool box. When it is not possible to match my tool, use another tool that will produce a similar cut. In general, what you need are gouges of different sweeps or curves, ranging from very deep U-shaped gouges to gouges with a very gentle curves. There should be a variety of different size tools, including some micro tools, because some of the carving cuts call for very small tools. Power tools that produce the same cuts as the gouges may be used. Personally, I rarely use power tools when carving on the actual face; I find I carve finer detail with hand tools. That is my personal preference. In carving, the only thing that counts is making the right cut. When you use the right tool for the cut, the carving process will flow faster and smoother and the end result will be a better carving.

Use the largest tool that will produce a particular cut. This concept will save you time and give you smoother cuts. A smaller tool can work adequately, but you will have to make multiple cuts to achieve the same results.

Notice that I use a large shallow gouge for all of my roughout work. My roughout tool is a gouge that was originally designed to be used with a mallet. I have wrapped the blade of this gouge with strips of rubber cut from an old car inner tube. The wrapped blade then becomes the handle and allows me to be able to comfortably grip the tool closer to the cutting edge. I carve with this gouge by rotating my wrist down and to the side. This allows the gouge to cut with a strong and accurate slicing motion. I often hold my other tools with "pencil grip" and wrap them with the rubber inner tubing for a better grip. Try holding your tools in these styles. These methods generate a lot of leverage, produce excellent control and are less tiring than many other ways of holding tools.

Notice in the pictures of me carving, some part of the tool hand is usually in contact with the wood. Try to have part of your carving hand in contact with the wood. This will give you more control over your cuts. You should be able to stop a cut at any time, in any portion of a cut. Learn to apply only enough pressure to your tool to execute the cut.

Carving Light

The proper use of light is rarely mentioned in carving instruction, yet it is one of the most important and useful tools that an carver uses. One must have good light when carving realistic faces because of the fine detail and subtleties inherent in the realistic face. It is impossible to carve realistic faces under poor light conditions. Carving in poor light is like trying to play a musical instrument that is out of tune, or like carving with tools that are incredibly dull. A carver with poor carving light will be unable to get good and consistent results and never be able to progress to full carving capability regardless of the subject matter.

Poor light is defused, bright and even. It is a light that does not cast shadows. Examples of poor light are the outside light of a bright overcast day or the

inside light found in a shop that is brightly lit with the florescent ceiling lights. Good lighting for a wood shop is usually poor lighting for woodcarving or sculpting activities. Light that strikes a carving from the wrong direction, or light that is too dim or too bright to allow the carver to see well is inadequate for good carving. Bright light that is coming from a side direction makes a carving area look bigger and dim light makes a carving area look smaller. Carving in a light that is too bright or too dim causes a carving to be carved out of proportion.

Good light is directional and casts shadows. Good light allows the carver to see the contours of the surface of the carving by producing the proper shadowing effect. Good light creates shadows that assist the carver in seeing the detail necessary to complete the carving. Good light causes minimal visual distortion.

A simple way to achieve good lighting is to use an inexpensive swing arm lamp, as you will see. Use a bulb that is comfortable for your eyes. I generally use a 60 watt bulb. By using the swing arm of the lamp you will be able to move the lamp to a position directly in front of you and your work area. Next, position your carving (or the light) so that the light from the lamp strikes the carving at about a 45 degree downward angle and you are ready to go to work. There can be background light, but the background light must be dimmer than the light that produces the shadows you need to see on the carving.

The carving in this book was carved using the lighting just described. As much as possible, the pictures of the carving in this book were taken from the view point of the carver, enabling you to see the carving from the carvers point of view. To get the best use of this book, match your lighting with mine. Match the position of your carving and your light with the examples in the book and the shadows that are produced by the carving cuts in the book will be the same as the shadows seen on your carving.

In the carving seminars, I give the students their own swing arm lamps and keep the classroom lights dim. The students must depend on their individual lamp in order to see their work. After two days of using light like this, I ask the students to turn off their lamps. I turn up the lights in the classroom and continue the class activities. It is at this time the students dramatically realize the difference between good and bad lighting conditions. Almost immediately the class requests that the room lights be dimmed and the swing arm lamps be turned back on.

One other way to use light as a tool is by adding a dimmer control to the lamp. In carving, some cuts are best made with a normal light but some more subtle cuts are best made with a dimmer light. The dimmer control gives a carver flexibility to quickly adjust the light.

In my carving shop I have on the ceiling three banks of parallel bright florescent lights running the length of the shop. Each bank is on a different switch so I am able to dim any portion of the shop. When carving in my shop, I use my swing arm lamp with a dimmer and I usually turn off the banks of lights in front of me and those over head, keeping the bank located behind me illuminated for background lighting. When doing very fine detailed carving, I completely darken my shop and turn off all of the overhead lights and use only the swing arm lamp with a dimmer.

I encourage you to experiment with lighting. Once the best lighting for a particular carving is determined, be sure to maintain that particular light for consistent results.

Soft and Hard Cuts

A soft cut is a cut made with a tool that does not cut a thin line. A soft cut happens when two surfaces come together without showing a distinct line or separation where the two surfaces meet. Such a line is made using a V-gouge or veiner that leaves a slightly rounded area at the bottom of the cut. A soft cut does not leave a distinct line or shadow. A soft cut is used to show where surfaces meet and blend together. Most lines of the face and most planes that intersect are soft cut lines.

A hard cut is where two surfaces come together and there is a definite separation line between the two surfaces. This cut is made by using a straight blade knife to cut a V-shaped channel. There will be a sharp line where the two surfaces meet. A hard cut always leaves a distinct line or shadow, and shows separation. Most cuts on faces are soft cuts.

What must I do in order to carve realistic faces?

A student asked recently, "What must I do in order for me to be able to carve realistic faces?" This is a question that I have asked myself for over twenty years of teaching about face carving. What must you do in order to carve realistic faces? You must learn to see faces differently than you now see them. When you see them differently, you will carve them differently. As the teacher, it has been my task to change the way students see faces.

Over the years my teaching methods have changed quite a bit. The results that have been achieved by the students have steadily improved as evidenced by what they have been able to do in class as well as what they have been able to achieve after the class is over and they have gone home.

This book is patterned after the seminar and includes the activities that have been found to produce outstanding results.

You will achieve the best results from this book if you imagine that you are taking my seminar and do the exercises in the book as they are presented.

When students first start to work with clay, some feel a little uncomfortable. This is a normal reaction, as working with clay will be like when you were first carving in wood. It takes a little getting used to, but you will adjust to the clay much quicker than you adjusted to carving in wood. Many of my students report that the clay work is one of the most enjoyable portions of the class.

There are many good reasons for using clay. First of all it is a wonderful teaching tool. It is fast. In minutes you can model in clay what would take hours or days to do in wood. Because it is so fast, you can practice a particular object or portion of an object over and over. You can easily experiment. It is very forgiving. If you cut off too much clay you can just add more clay to cover up your mistake, something you cannot do in wood. Working with clay provides your brain with more information about the subject matter you are working on. You have your hands and fingers in contact with the material and this sends tactile messages to your brain. You are learning with your sense of touch as well as with your sense of vision. You are also learning with the right and left hand . Any sculptor will tell you that the best tools you have besides your eyes are your hands and finger tips. A general rule is you never do anything with a tool that you can do with your fingers. What is learned in the clay is directly transferrable to wood. In the seminar I can guarantee you that if you work with clay you will improve your carving ability much faster than if you worked only in wood.

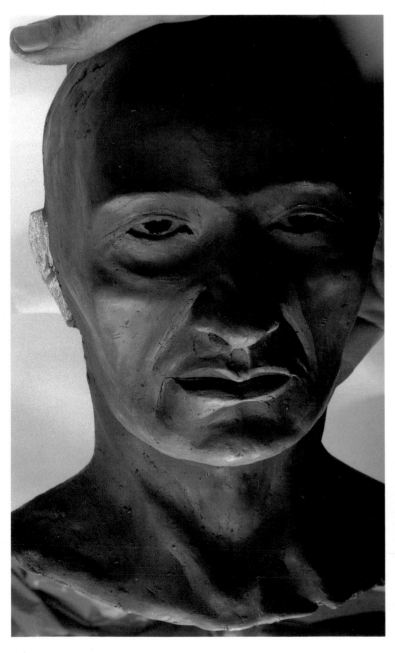

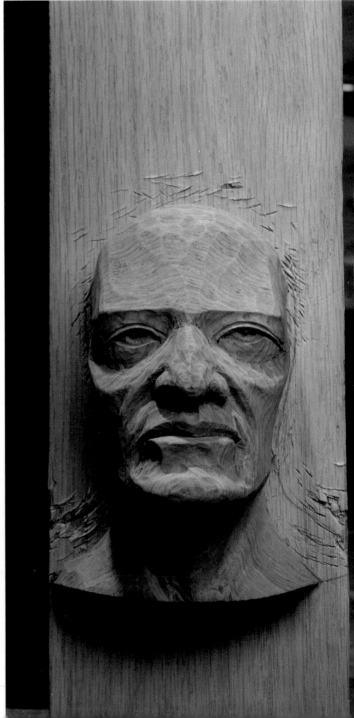

Basic Proportions
of the
Head & Face

Every head and face is different and the proportions will vary from face to face. However there are some standard proportions which are very useful to know. Knowing these proportions will assist you when viewing faces and also when carving. By knowing these proportions and using them as a guideline you are more likely to carve realistic looking faces and you will avoid some of the more common errors that are found in carvings of faces. These proportions also serve as a reference when viewing and discussing faces.

Take the time to get well acquainted with these.

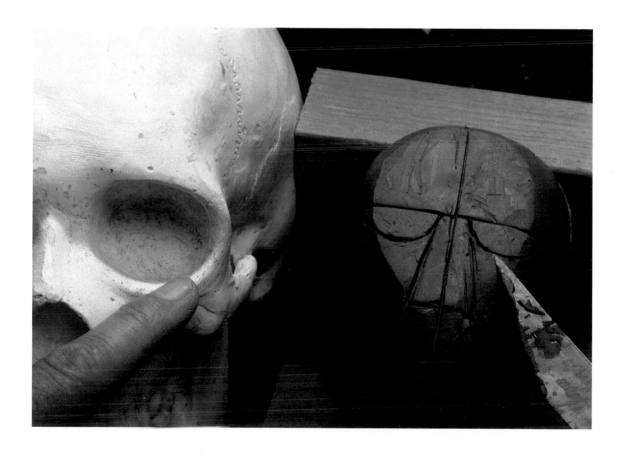

Proportions of the Head

A head is 5 eyes wide

The facial area, the area below the natural hairline, is divided into three equal portions: the chin to the bottom of nose; the bottom of nose to the brow line; the brow line to the natural hair line. The natural hair line is about 1\10 the length of the head.

The center of the eyes is half way between the top of the head and the chin.

There is one eye width distance between the eyes.

The corners of the mouth extend to an imaginary line drawn down from the centers of the eyes.

The bottom of the nose is about one eye width.

The portion of the head between the chin and nose is divided into three equal sections: The bottom of the chin to the top of the chin; the top of the chin to the lip line; the lip line to the bottom of the nose.

The bottom of the ears is located across from the area between the mouth and nose. The top of the ears are across from the brow line.

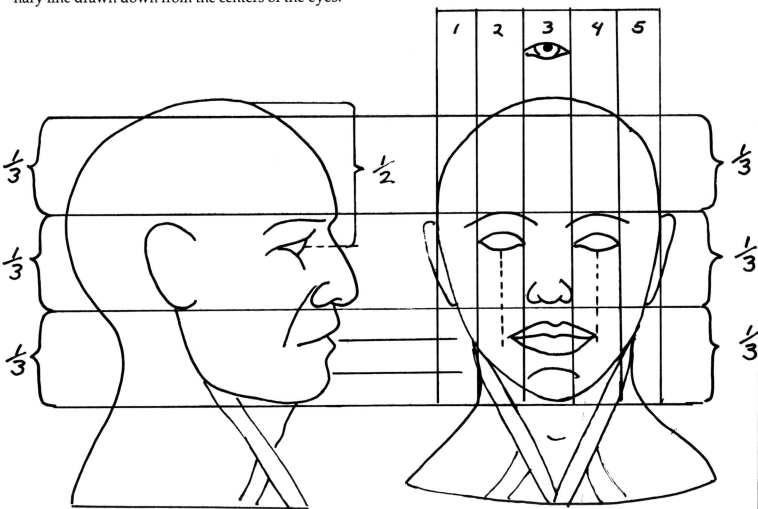

The head fits roughly into a square.

The head is about three-fourths as wide as it is deep.

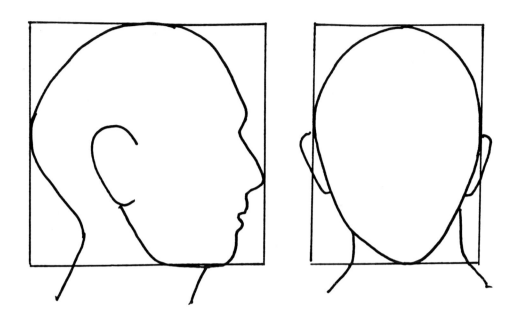

A line extended across the bottom of the head just below the ears is equal to the distance from the chin to the brow line and the distance from the tip of the nose to the front portion of the ears.

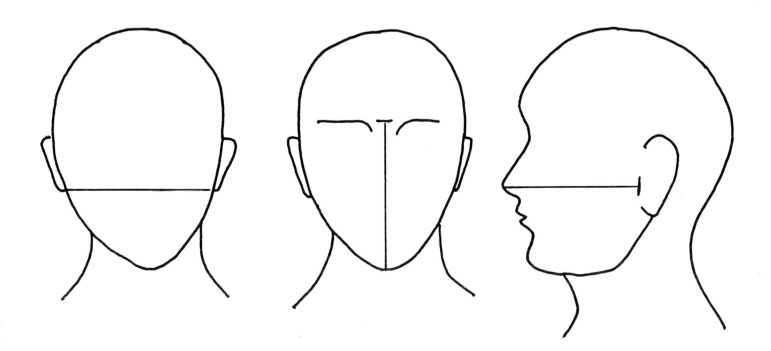

Materials

Before you start the exercises in this book you are going to need the following materials.

Clay
Basic Clay tools - Wire loops, wooden modeling tools, cutting tools
Clay Cutter
Wedging Board
Calipers
Clay board
Plastic bags
Towel & Hand cream
Templates - 2
Swing arm lamp

Clay

You will need about 10 pounds of moist ceramic clay. This is the same type of clay that potters use to throw pots on a potters wheel. It can be purchased at any ceramic supply shop and at many art supply stores. If you have trouble locating the clay, look in the yellow pages of your phone book under ceramics or clay, and call a local dealer and ask where you can get the clay. The clay is inexpensive. A twenty pound plastic bag of moist clay should cost under ten dollars. The clay can be used over and over and will be useful for working with many different carving projects.

Basic Clay Tools:
Wire loops, wooden modeling tools, cutting tools.

Clay tools can be purchased at art supply shops or they can easily and much more economically be made by you. I make all of my own tools (see page 15). In the classes, the students make their own tools. Wire loops are made by bending a stiff wire and gluing the wire into a dowel which has holes drilled in the end. The wire I use is musical wire purchased at a hobby shop for under 25 cents for a 3 foot piece. The wooden modeling tools or paddles are carved from wood and sanded smooth. I also use a all purpose modeling and cutting tool made from apiece of metal banding which was originally used to hold lumber together. The local lumber yard gives me all

I need for classes. You will also need a cutting tool for cutting larger pieces of clay. Such a tool is made by made by attaching a 12 inch length of wire to two wooden handles. The cutter is used by drawing the wire through the clay.

WEDGING BOARD: A wedging board is simply a board that clay can be pounded against to force moisture into the clay. A wedging board can be made by using a piece of half inch or thicker plywood or a similar board 18 inches square which is then covered with a heavy cloth which is stapled to the board. When your clay dries and is difficult to work, you can bring it back to working consistency by cutting the clay up into little pieces about the size of ice cubes with the cutter, sprinkling them with water and then pounding the moistened pieces back into one piece by pounding them against the surface of your wedging board. Pounding the clay back together forces the moisture evenly throughout the clay and it will be ready to be worked again. In this way clay can be used over and over.

CALIPER: You will need a caliper that is six to eight inches long. For the class I make my own out of hard wood.

CLAY BOARD: It is useful to have a wooden board about 18 inches square on which to work and keep your excess clay.

PLASTIC BAGS: You will need several plastic bags to store your clay and to cover your projects to keep them from drying out. Produce bags from the local grocery store work well.

TOWEL and HAND CREAM: The clay dries out your skin. Using hand cream while you work prevents this. It is also handy to have an old towel to wipe clay from your fingers.

TEMPLATES: Two (2) needed

SWING ARM LAMP: To enable you to always control your lighting while you are working.

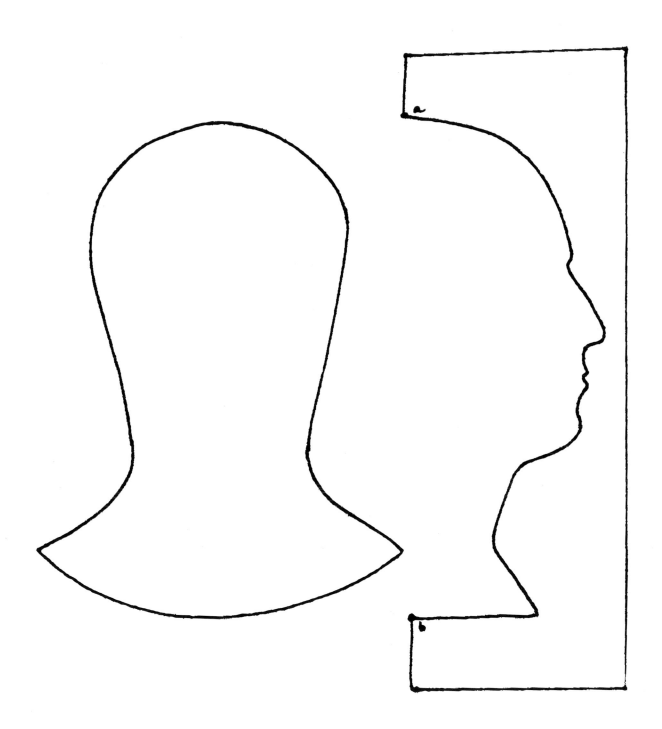

Exercise 1

Self Assesment:
Determining Your Present Understanding of Faces

This exercise is the first exercise presented to the class. It is very important in that it will establish a base line for future comparisons. In addition it will focus your understanding of what you presently know about faces. Later it will allow you to judge your progress.

The clay we use is a water-based ceramic clay. You could use a soft oil-based clay, such as Romalina Plastalina™, or Sculpey™.

Instructions

You are going to model a face in clay using only the tools and your memory. Time yourself. Allow 1/2 hour to complete this face. Start by covering the small templet with clay about two (2) inches thick. The templet will serve as the outer boundaries of the face. Using your clay tools, model a realistic face. Model only the portion of the head from the front of the ears forward. Put in only the basic features: eyes, nose , mouth and facial plains. Do not include any hair or mustache or beard. Do not add ears. Do not use any references or pictures. Do not go on in the book until you have finished this exercise.

Cut two forms from 1/4" masonite or plywood, using the pattern on page 13.

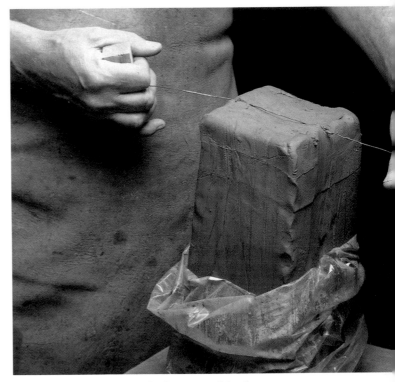

Use a wire to cut enough clay to model a face.

A block of clay about this size should be adequate.

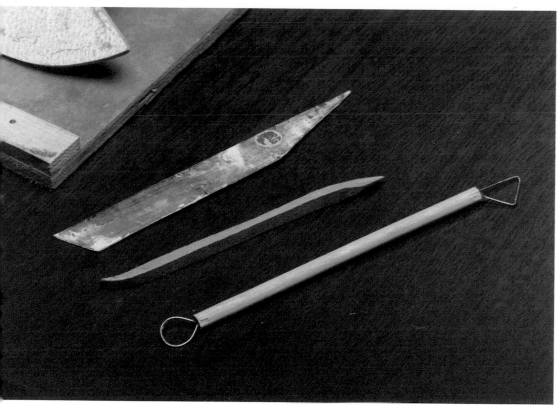

These are the three basic clay tools I use: a metal cutting tool, a wooden shaper, and a tool with wire loops, one round and one triangular. The first exercise is simply to use these tools to model a human face in full relief from the front of the ears forward, as well as you are able. Allow yourself just one-half hour to accomplish this.

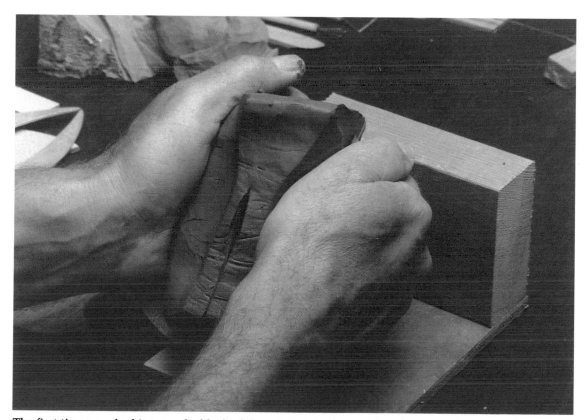

The first time you do this press the block of clay against the form and go from there. We're not going to give you directions. Instead just use your innate talent. Don't turn the page until you are finish! This is the honor system, but remember the purpose of the exercise is to find out what you presently know.

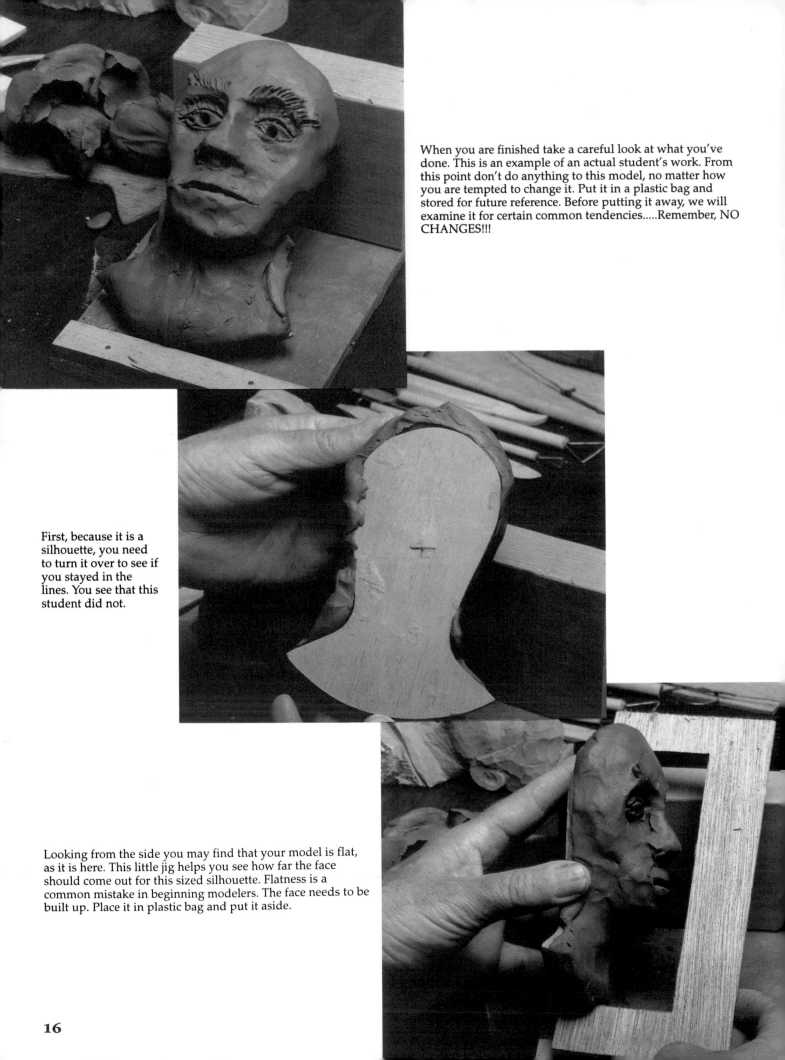

When you are finished take a careful look at what you've done. This is an example of an actual student's work. From this point don't do anything to this model, no matter how you are tempted to change it. Put it in a plastic bag and stored for future reference. Before putting it away, we will examine it for certain common tendencies.....Remember, NO CHANGES!!!

First, because it is a silhouette, you need to turn it over to see if you stayed in the lines. You see that this student did not.

Looking from the side you may find that your model is flat, as it is here. This little jig helps you see how far the face should come out for this sized silhouette. Flatness is a common mistake in beginning modelers. The face needs to be built up. Place it in plastic bag and put it aside.

Exercise 2
Determining the Proper Depth
for a Face

One of the first steps in modeling a face is determining the volume. There is a simple principle: the width between the ears...

Moving to the template we need to establish the jaw line. As a rule a head is 3/4 as wide as it is long. The template measures 3"...

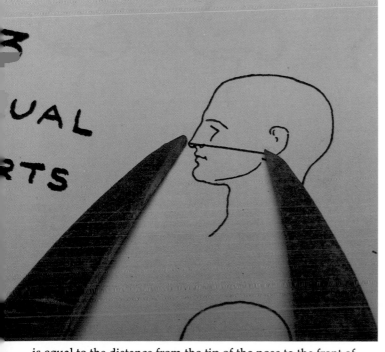

is equal to the distance from the tip of the nose to the front of the ear.

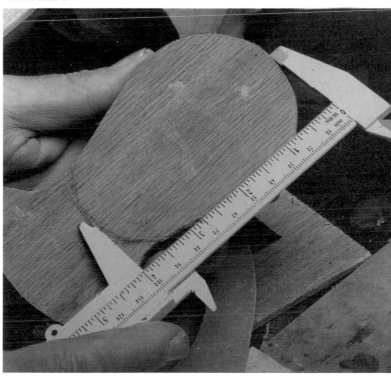

so the length must be 4".

With the length of the face determined you can visualize and measure the location of the ear on the second template you cut. This will be the depth of the face from the nose to the front of the ear.

When you are almost done, turn the template over and check that you stayed within the boundaries of the template.

Place clay on the front of the template and build it up to the measured depth.

Trim any excess, being sure none of the clay hangs outside of the template.

After you establish the depth you fill in the mass of the head.

Smooth and shape the clay to the basic head shape.

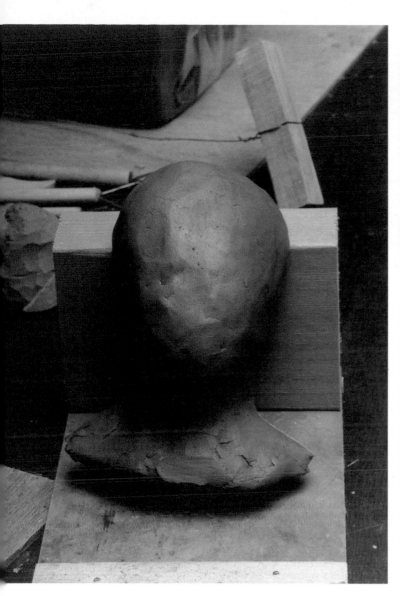

Progress.

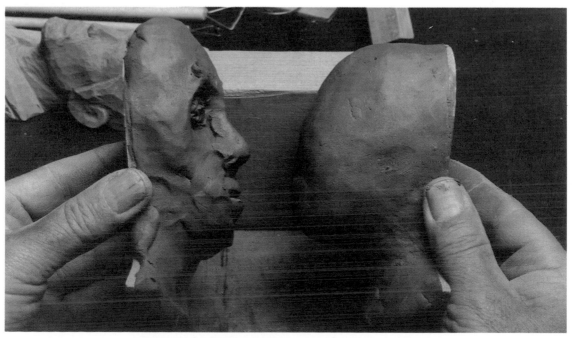

Take your original out of the bag and compare. You can see
how its depth compares.

Exercise 3

Facial Planes

The face is divided up into a number of definite surfaces or planes. These make up the underlying structure for the facial features. The planes are formed by the bones and muscles of the head and neck, and will be more or less visible in every face. A face carving which does not include the facial planes will always be lacking in realism and character.

Before we go any further, we are going to have to adjust the lighting to enable us to model the fine discriminations necessary to put the planes on the head and face. Without proper lighting it is virtually impossible. You need a single source light shining from directly above the head you are working on, striking the surface at about a 45 degree angle. A simple swivel-arm desk lamp works well. To the eye the bright side of an object will look larger than the side in shadow, so it is important that the light source is balanced on both sides.

Stick your tool in the center of the forehead so it casts a shadow down the center of the face. This helps you get the face's bilateral symmetry.

With a tool draw a line down the center of the face through the cast shadow, dividing the face into two equal sides. Be as accurate as possible.

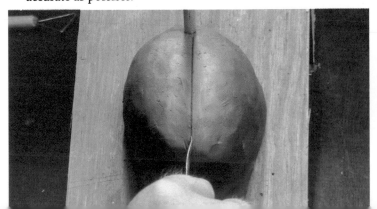

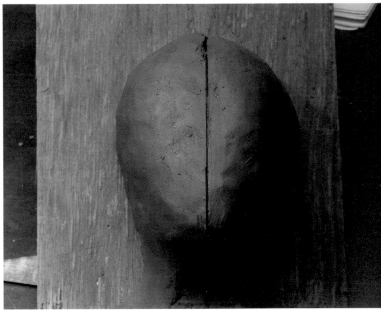

One side illuminated...

and the other. You can see the effect the light has.

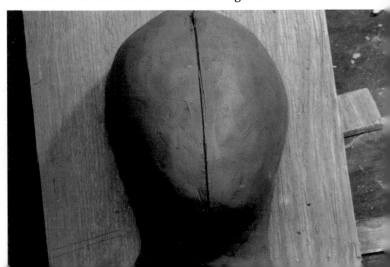

The light set up. Use a 60 watt bulb.

Use calipers to divide the face in thirds, top to bottom, with a bit extra at the top for the hairline (1/10 of the length of the head.) *See facial divisions.*

Mark off the hair line, then draw lines across the face at the 1/3 marks.

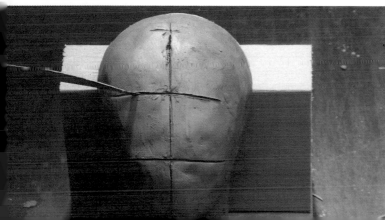

Extend the lines around to the side.

Mark a spot half way from the bottom of the chin to the very top of the head. The line is the center of the eyes.

These lines are for orientation.

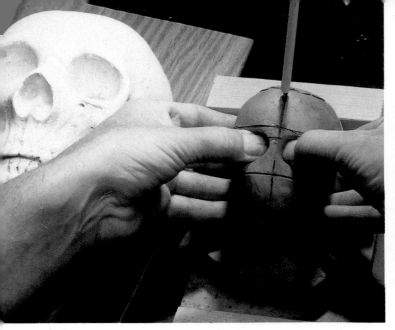

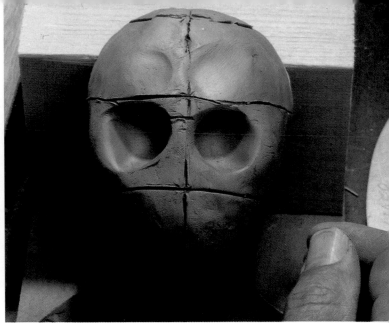

Make the eye sockets using your thumb.

The result.

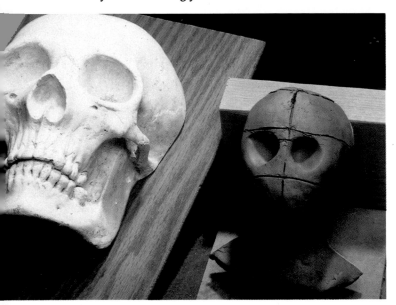

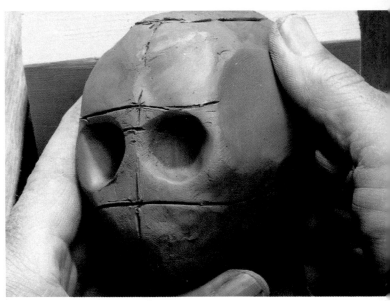

These sockets now become reference points for the planes of the head.

The temporal plane starts at the outside edge of the eye socket and goes back into the temple.

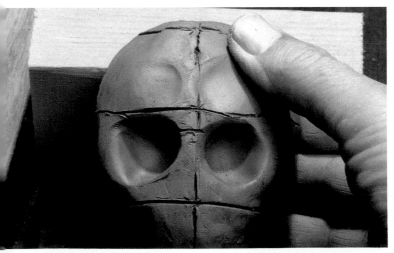

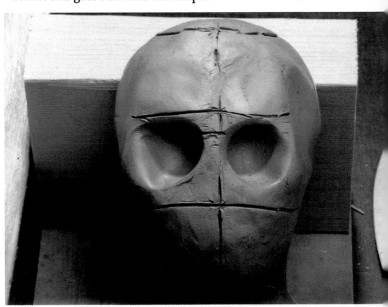

The forehead planes start beside the center line in the lower corners of the forehead quadrants and sweep out and up. Use you thumb to create these planes by pushing in and dragging. Although I've done one at the time, you can do both at the same time.

The result.

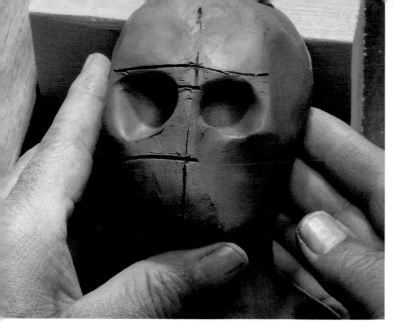

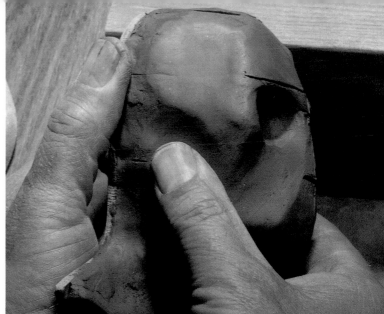

The next plane starts at the inside edge of the eye socket, runs along the nose and under the cheek bone, down to the jaw.

Pull down from the bottom edge of the cheek bone to the back of the jaw to form the next plane.

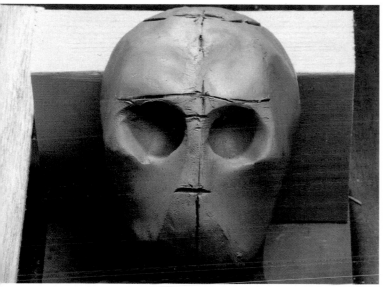

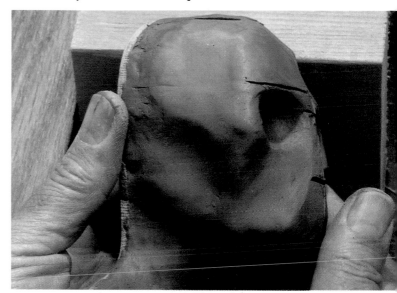

Progress.

The result. Repeat on the other side.

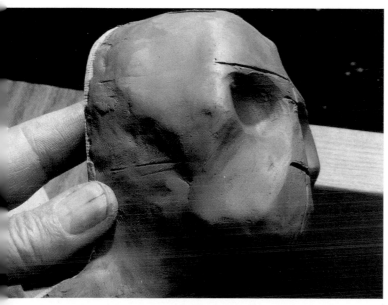

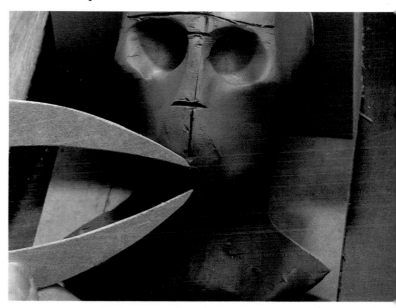

The plane comes quite far back on the side of the jaw. There is a tendency is to stop it too soon and make it too thin.

The chin goes up 1/3 of the distance from the bottom of the face to the bottom of the nose.

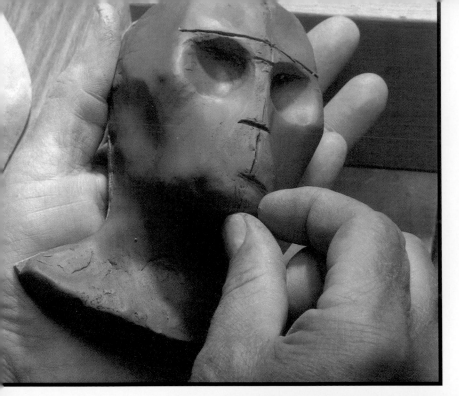

Hold your thumb at the bottom of the jaw, and pivot around the chin pushing in with your forefinger.

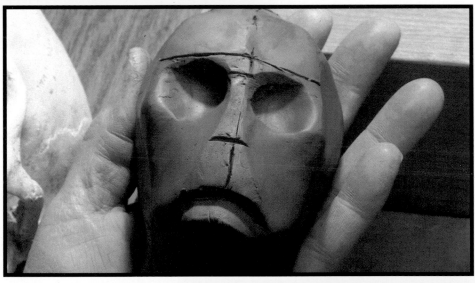

Push in under the nose to form the line of the upper lip.

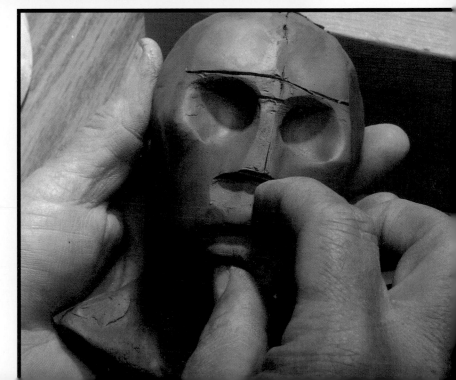

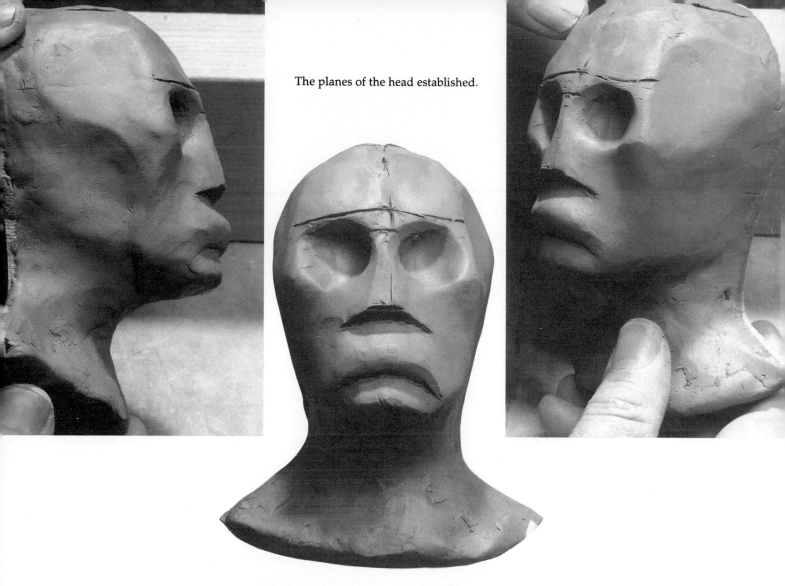

The planes of the head established.

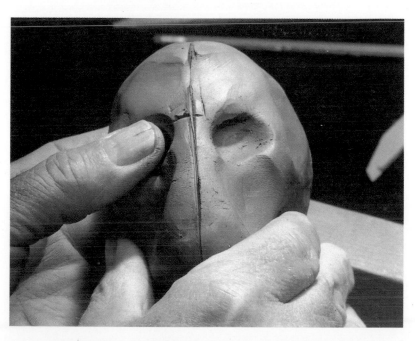

A good practice exercise at this point is to reshape the clay to take away all the planes. Draw the center line and the make the eye sockets. Then, with eyes closed, reform the planes of the face. This takes helps you get a feel for the face.

Exercise 4
Carving the Facial Planes in Clay

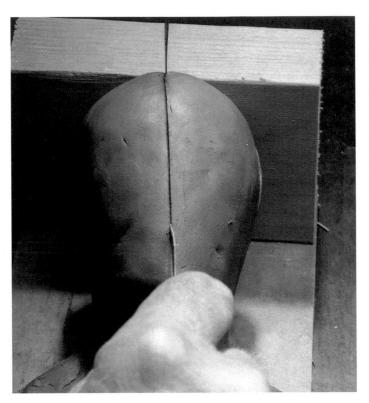

Remold the head and establish the center line.

Measure from the back to the tip of the nose.

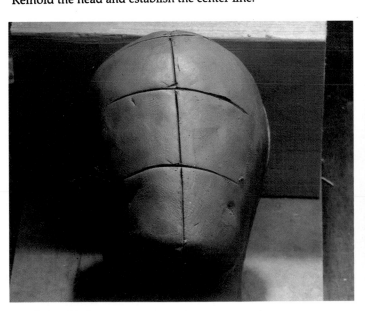

Mark the thirds.

At the top of the head mark the scalp 1/3 to 1/2 the distance back from the tip of the nose.

Slice from the tip of the nose back to this line.

and draw it in.

The result.

The nose is about a third of the width of the face at this line.

Reestablish the eye line...

From the brow mark the orientation lines for the nose.

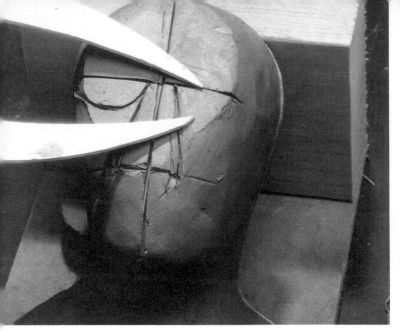

Measure down one third of the way from the brow line to the nose line and mark.

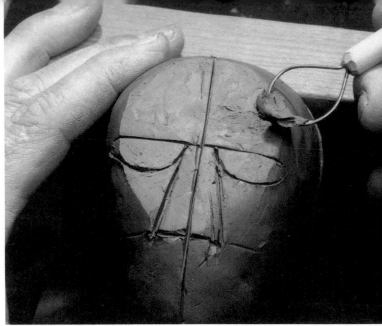

Carve the planes of the forehead with a wire loop. Because woodcarving is an art of subtraction, this more closely matches the skills you will use in carving.

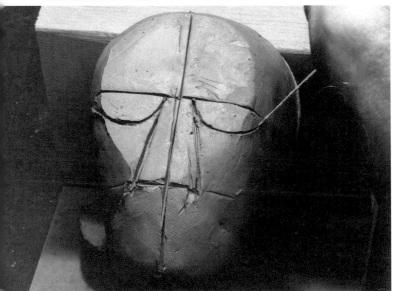

Draw a curved line from the point where the nose line meets the brow line, coming down to the mark and carrying around to the side of the face.

Cut the temple area. This is the first cut.

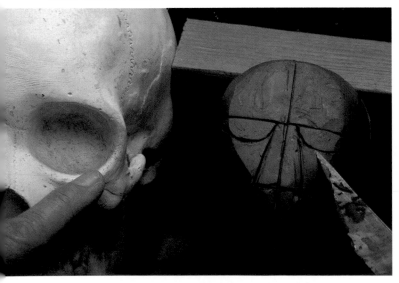

These semi-circles represent the bottom edge of the eye socket.

From there you widen the area to achieve the same shaping you did earlier with your thumbs.

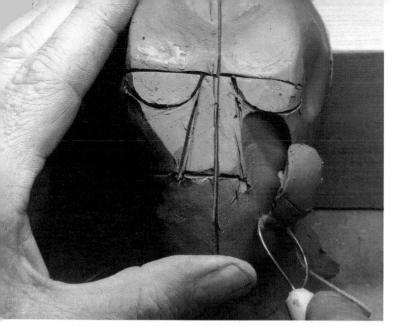

Come down beside the nose and carve away this plane. This is a fairly deep cut here, though each face will be a little different.

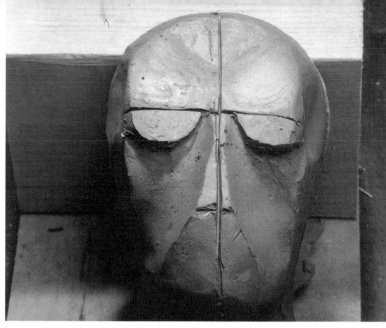

Repeating on the other side we get to this point on the front...

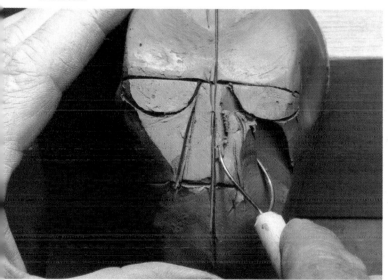

Start at the bridge of the nose, between the nose and the eye socket, and, with the edge of the loop, go in and come down beside the nose at an angle.

and this point on the side. Remember, this plane comes quite far back on the jaw bone.

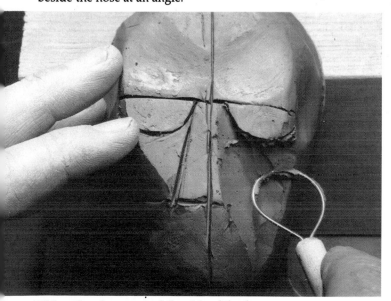

Widen the plane around the side of the face.

TIP: Get in the habit of keeping your clay trimmings in a ball. This will keep it moist longer.

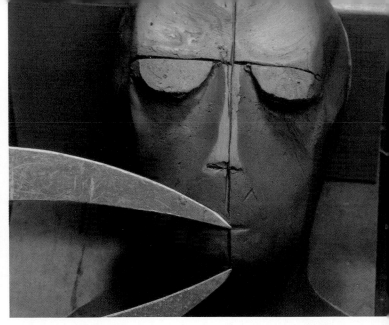

Measure 1/3 of the way from the chin to the bottom of the nose.

Carve away the plane below the cheek...

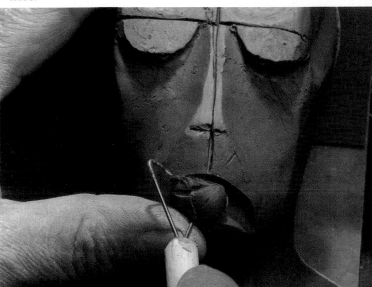

With the corner of a triangular wire tool, cut an arc that goes through this line.

for this result. Repeat on the other side.

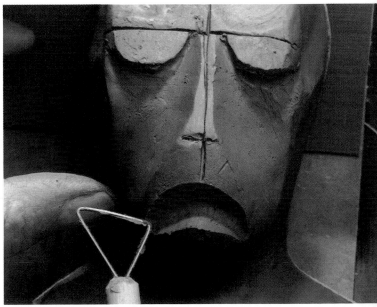

The result.

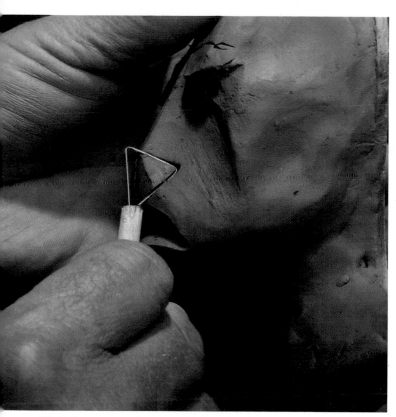

With the same tool come across under the nose...

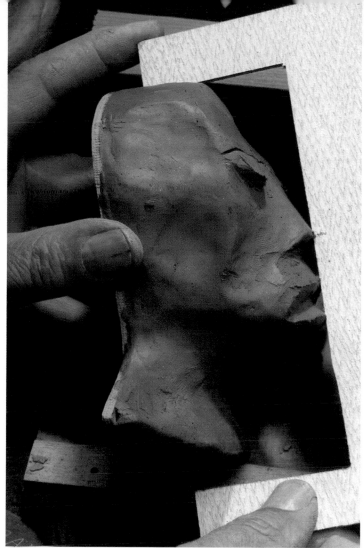

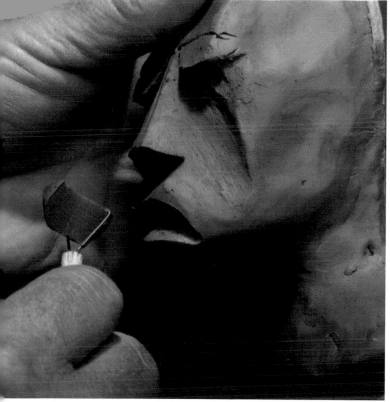

to shape the upper lip plane.

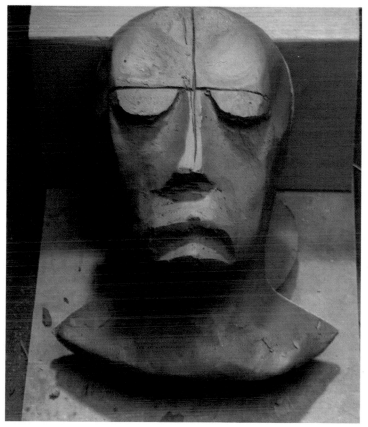

Progress.

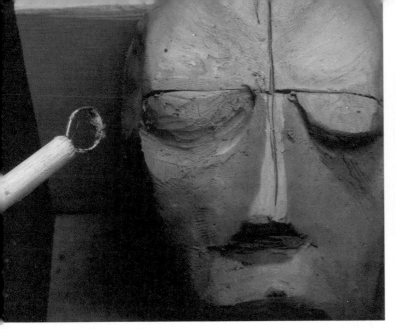

Round the eyes off.

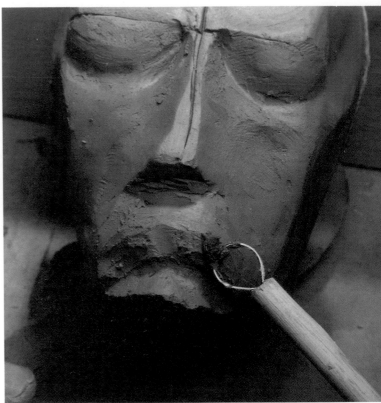

There is too much material in the mouth mound, so reduce it.

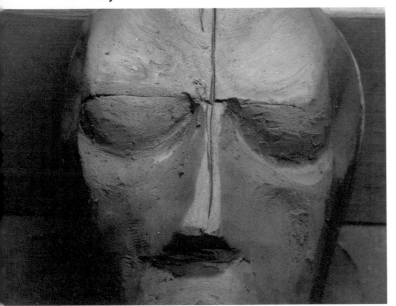

From this basic shape you can shape any type of eye.

Side view.

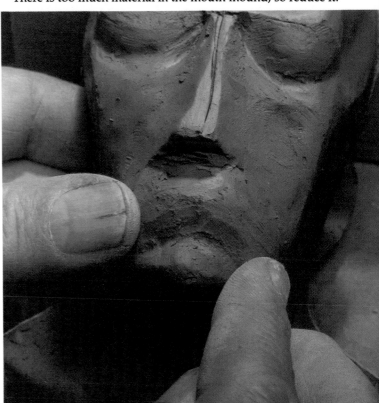

With your fingers smooth away some of the sharpness of the chin, the top of the forehead, and where the planes come together. You could carve this away.

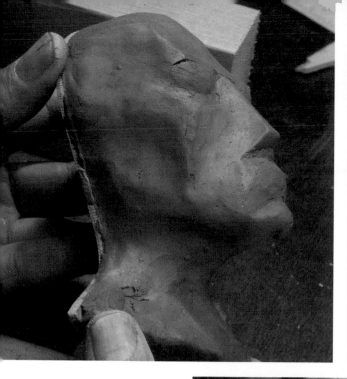

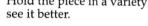

Hold the piece in a variety see it better.

of positions to help you

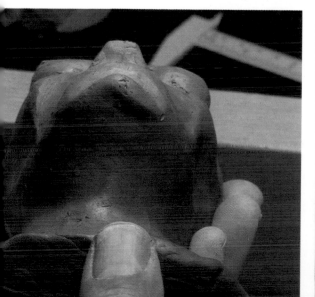

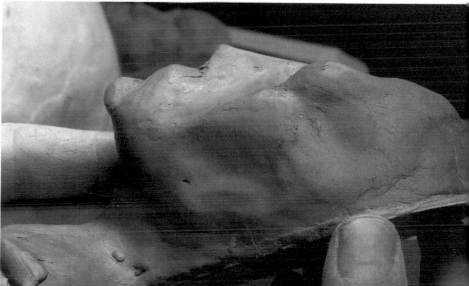

Exercise 5

Details:
Facial Features, Eyes, Nose, Mouth & Neck

For this exercise we use a template that is twice as large as the one we have been using (see page 13). With this larger, life-sized face, we can study the features much more finely. Each feature has its own planes, just as the face does, and at life size we can explore them more completely. With the larger size we also can use our fingers as tools. This is im-portant because there is a direct connection between the material and the brain when you are using your fingers. Without tools, the input directly from your fingers is much greater and will help you learn much more about the face. Any sculptor will tell you that the finest tools you have are your fingers.

Here you can see the slant of the sides of the block. The block is cut from a 2 x 6.

Apply water-based clay to the template.

Enlarge the drawing 200 percent and cut a template from plywood. On the front glue a block of wood 1 3/4" or so thick. This fills space so you don't need as much material, and with the sides tapered in toward the template, it anchors the clay.

Attach the block with screws.

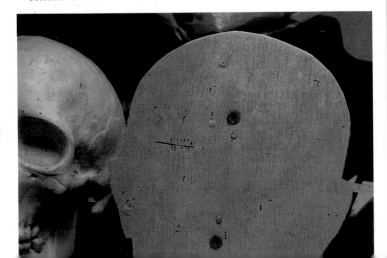

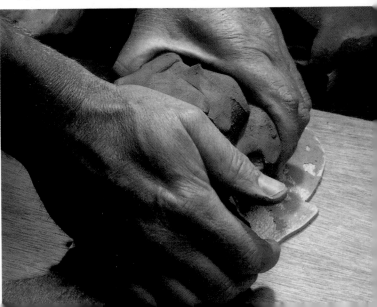

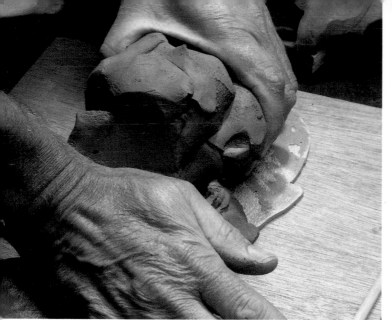

Push the clay down and slide it onto the template.

Establish the basic shape of the head and neck.

You can do the same thing with your finger. Push down...

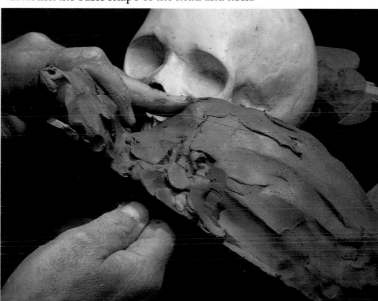

Trim the edges down to the edge of the template.

and slide. This is an efficient way to move clay.

Measure the width at the base of the ear...

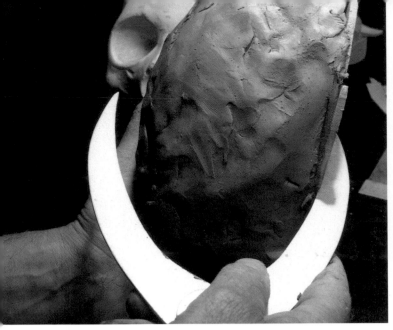

and check the distance from the back of the head to the tip of the nose. You can see that I need to add more mass. I've been at this for twenty years, and I still need to use calipers to get it right.

Add enough clay to build up the mass to the correct depth.

From the enlarged (200%) pattern cut a template out of stiff cardboard (see page 13).

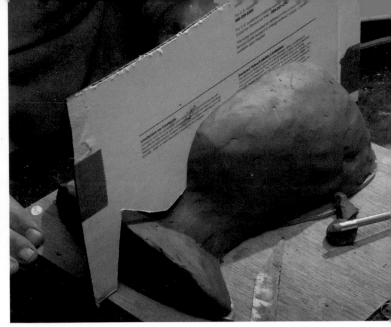

Push the template down into the center line of the face. Look for any gaps between the clay and the template, like here at the neck.

If you have any gaps fill them. Remove the template and bring the mass to the proper dimension, like I'm doing on the neck.

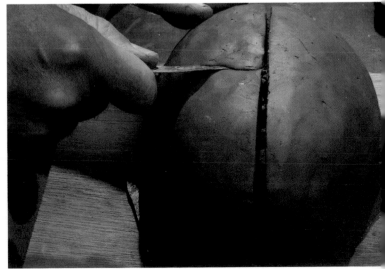

If some of the clay is too high, cut the sides down to the level marked by the template.

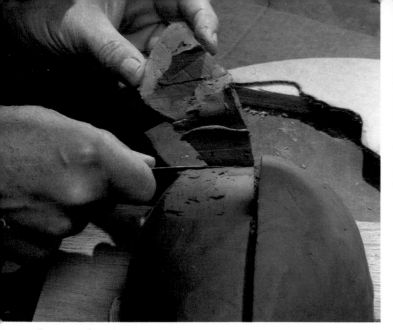

Remove the excess.

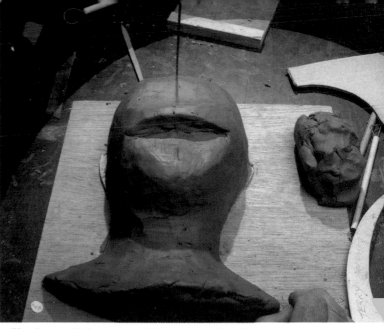

Check your lighting by sticking a straight edge in the forehead and aligning the shadow to go down the center of the face. This shadow line acts as a center line for your carving

Check with the template.

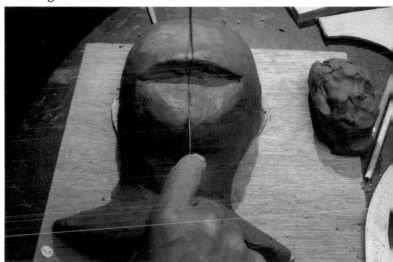

Mark the center line.

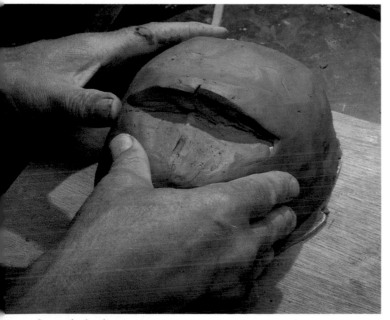

Smooth the face mass.

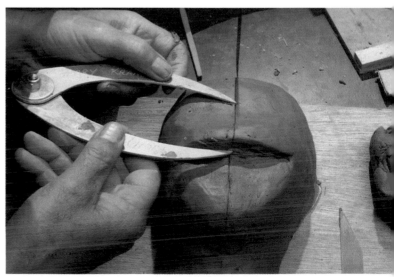

Divide the face in thirds. The first third, from the chin to the bottom of the nose, is established in the template. Transfer this measurement from the nose to the brow, and from the brow to the hairline.

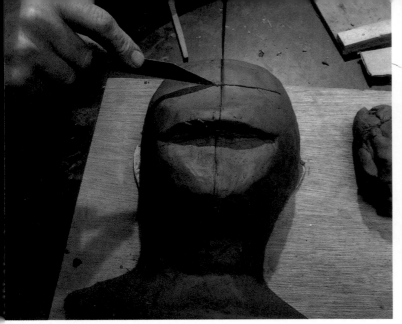

Make a reference line in the brow.

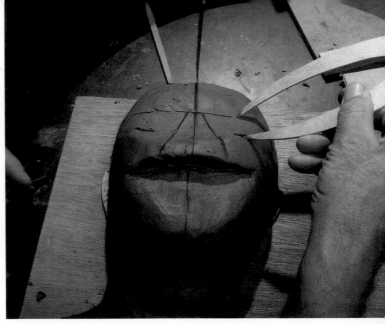

and mark it.

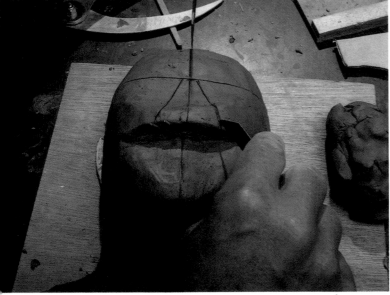

Establish the lines of the nose. This is done by eye, so the base of the nose is about a third of the width of the face.

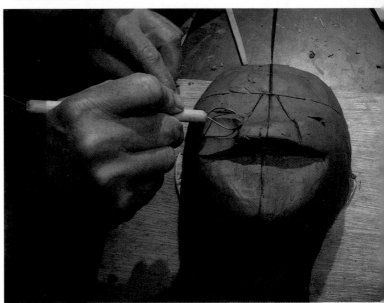

Remove the mass beside the nose. Don't go too far or you begin taking away the cheeks, which creates problems.

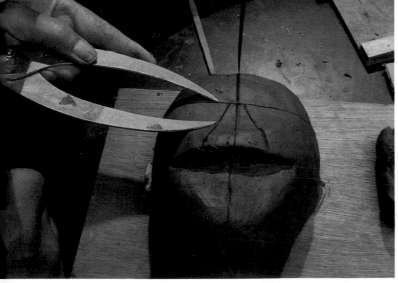

Measure halfway between the bottom of the nose and the brow...

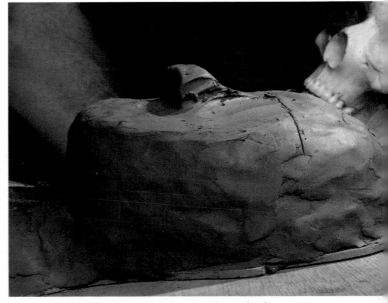

Here you can see the rise of the nose from the face.

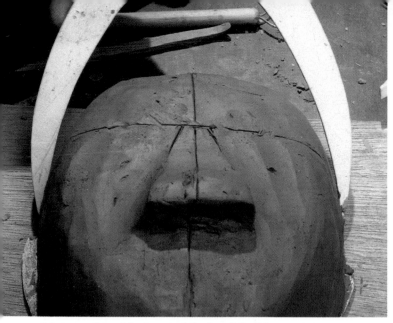

Measure the widest part of the head. In this case it is 6 inches.

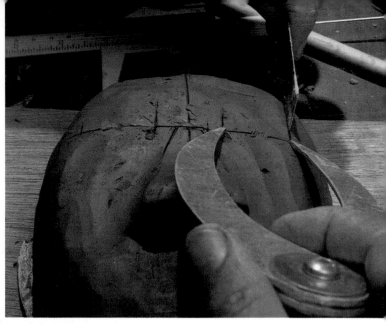

and the other.

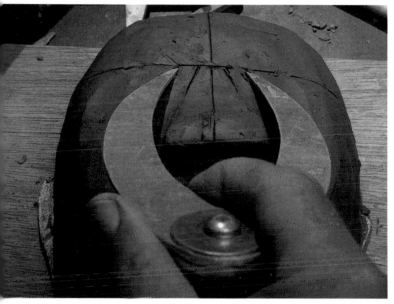

The size and placement of the eyes is based on imagining five eyes across the face. The eyes fall in spaces 2 and 4. Divide the width of the head by five, which gives us a little less than 1 1/4" for each segment. Set the calipers, center them on the brow and mark.

Reestablish the line that is halfway between the brow and the bottom of the nose. Use the caliper and a ruler to set an accurate point...

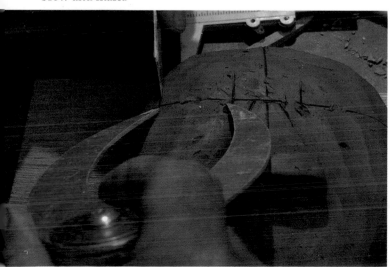

From there, mark the width of one eye...

and draw a line.

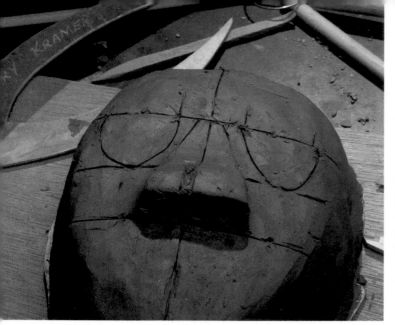

Draw the lines of the eye sockets.

Cut away the planes of the temple.

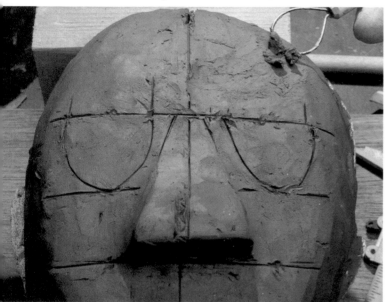

Put in the forehead plane. Move from the center and sweep out. This gives you a much better flow than going the other way.

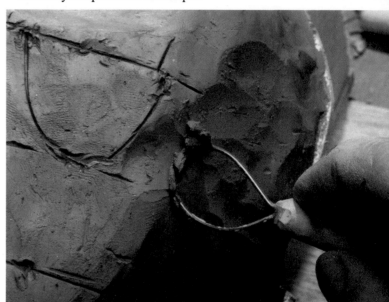

This plane really starts at the corner of the eye.

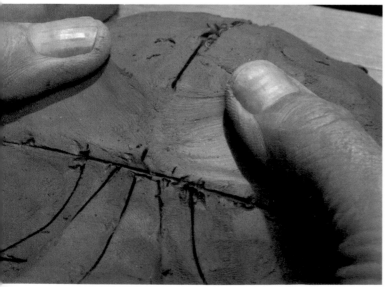

Use your thumbs to smooth and blend the forehead planes.

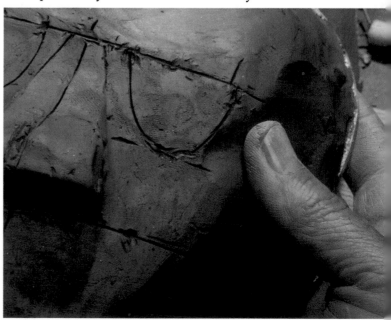

With the thumbs smooth the temple planes down.

40

You can also use the heel of your hand for this shaping. If you move your hand to your own temple you can feel the contour of the plane.

and come down beside the mouth with a nice deep cut.

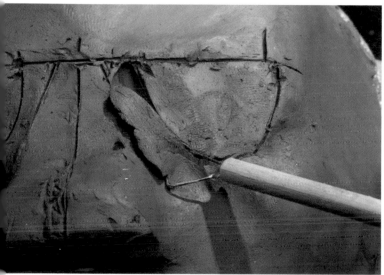

Start between the eye and the nose and cut around the eye socket. With the triangular wire I've gone in about 1/4".

Widen the plane and carry it around the side of the jaw.

Switching to a wire loop, start beside the nose...

The result.

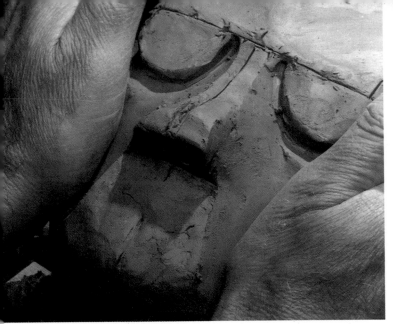

Use the heels of your hands to smooth it out.

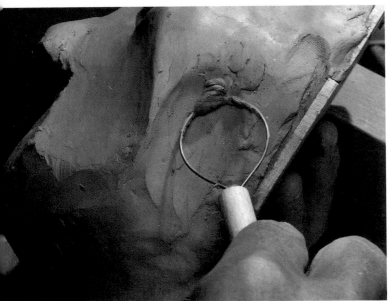

Establish the planes at the sides of the head.

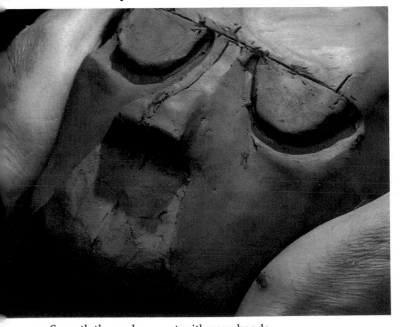

Smooth these planes out with your hands.

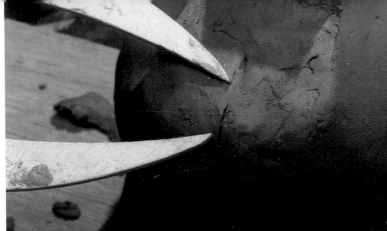

Set the distance one third from the chin to the nose.

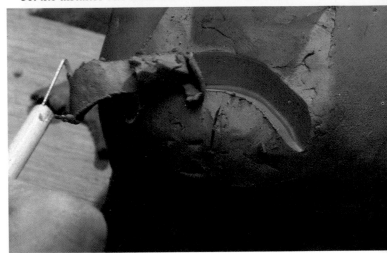

Carve the arc of the chin plane.

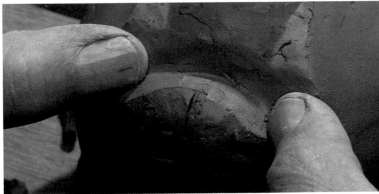

Clean it up, then smooth it with your fingers.

Blend the edges of the planes. While I'm here I give the figure a stronger jaw line.

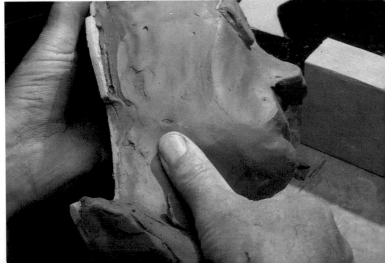

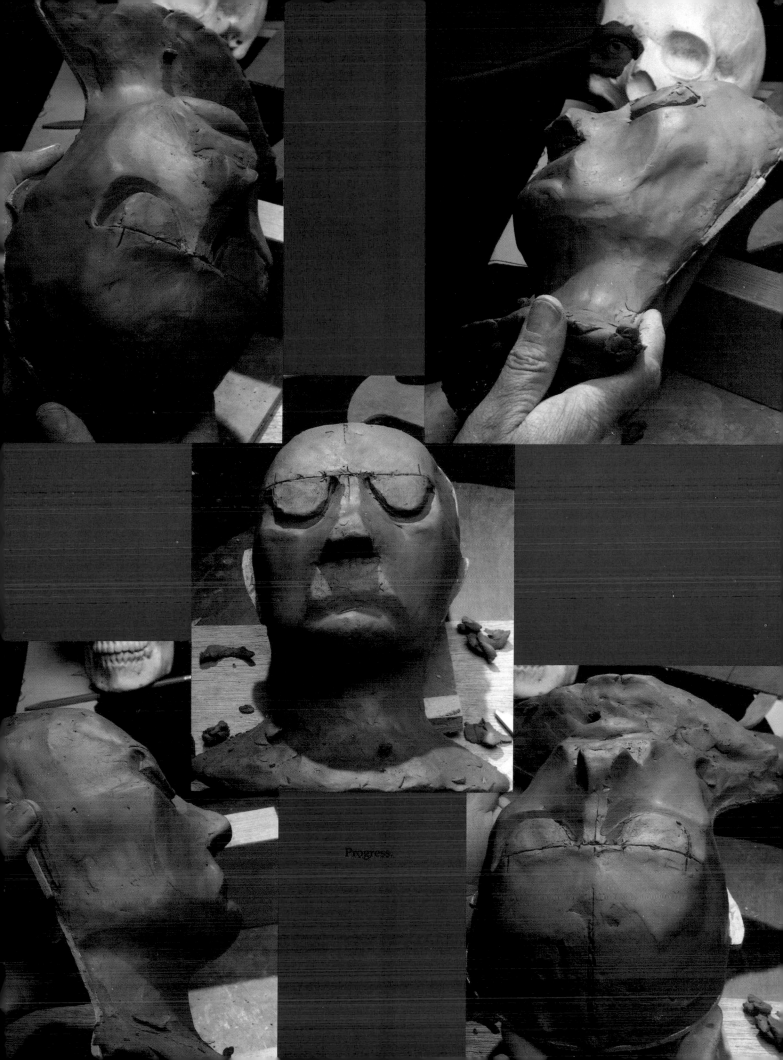

Progress.

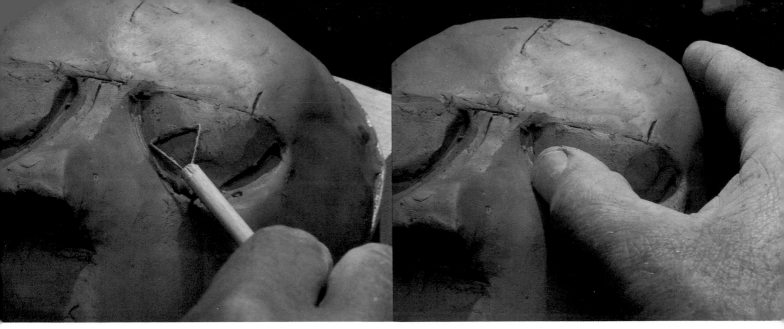

Round the eye areas...

and smooth with the fingers.

Progress.

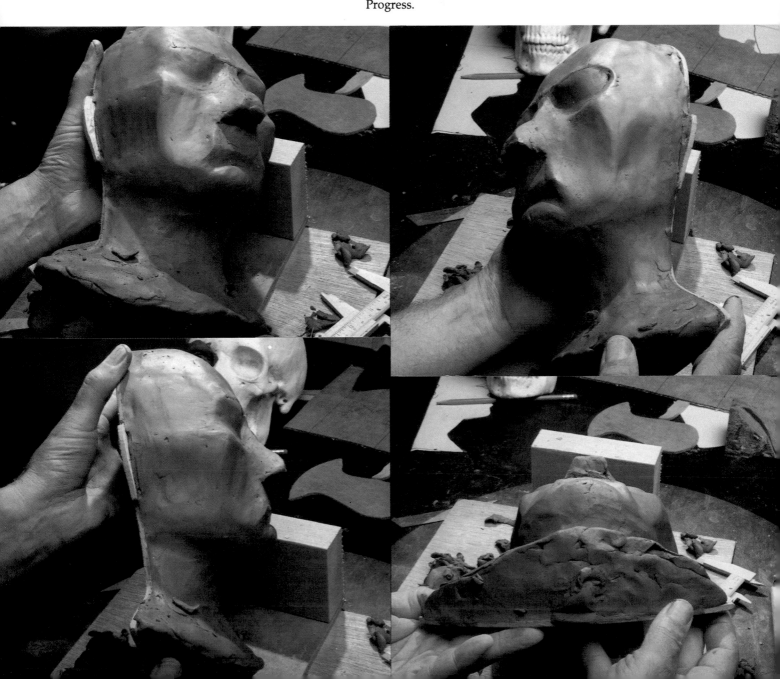

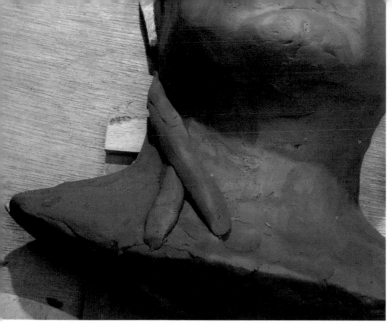

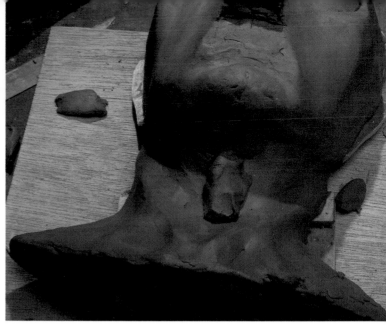

Lay in the muscle that runs from behind the ear to the center of the sternum. This is an important part of the overall look of the head and face. It branches out just above the sternum. Add rolls of clay to use for the muscles.

On males we can add the Adam's apple.

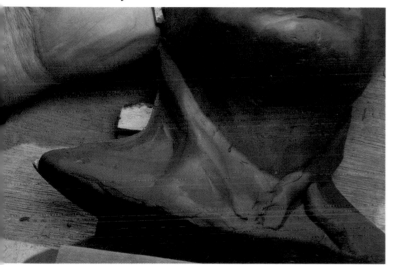

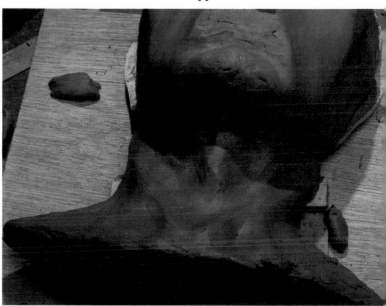

Blend and shape the muscle. You want to be sure you are every bit as careful in creating the neck as you are with the head.

Shape and blend.

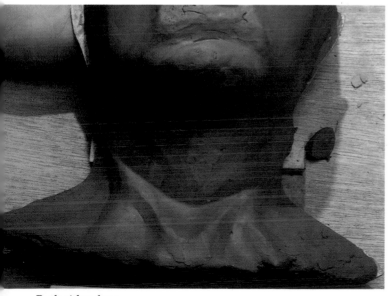

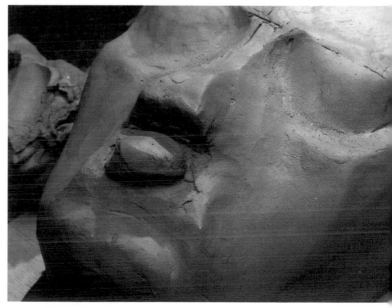

Both sides done.

I want to add some mass to the lip area, so I apply some clay...

and blend it in.

to approximate the roundness of the face.

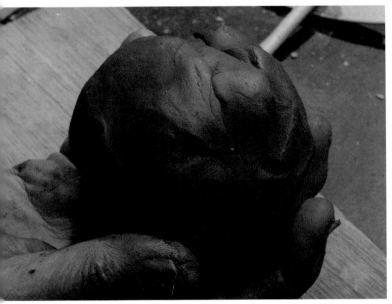

Before you begin the feature details, take some time to practice. When practicing features you never want to work on a flat surface. To practice making a nose. Take a piece of clay about baseball side...

On this place a cone of clay.

and flatten it out...

Add two buttons of clay for the nostrils.

Cut the bottom edge so it comes down in the center of the nose.

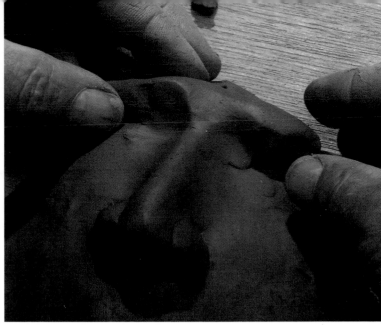

The brow line, which we have added to the practice piece, also blends into the nose.

You should be able to pinch the bottom of the nose, like you can on your own.

There is a fairly sharp line around the corner of the nose, which can be created with the triangular loop.

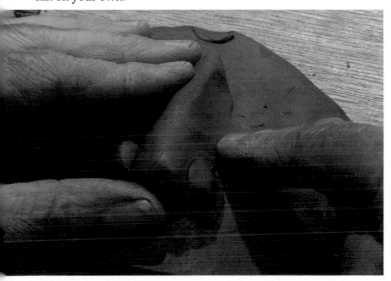

Blend the surface together, spreading the main cone into the face. You need to remember that the nose runs out into the cheek without a distinct line.

The cheek is shaped beside the nostril, starting at the top and coming around the side.

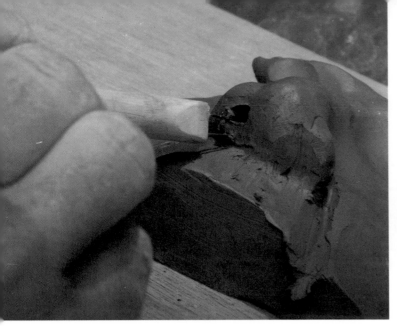

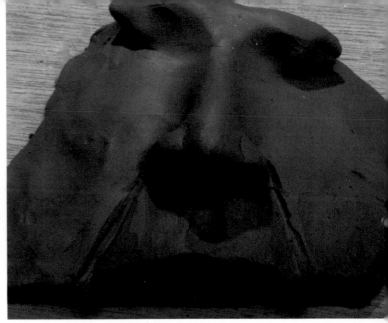

The holes in the nostril should be added after the outside is totally completed. If you make changes to the exterior after the holes are made you may end up with very thin nostril walls, which will look unnatural. Cut them out with a thin loop.

This is a fairly well-shaped nose, but we can improve it by paying closer attention to the planes.

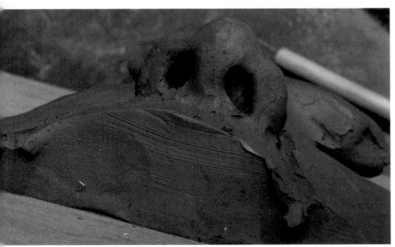

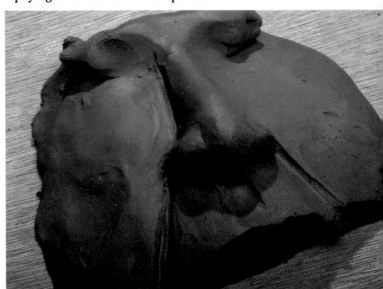

The result. It is interesting to look up people's noses and see the varieties in nostrils shapes. One thing that is a general rule: you almost can't make the nostril walls too fat.

Things to avoid: 1. Don't make the line of the nose too sharp. This is a common problem, especially for wood carvers.

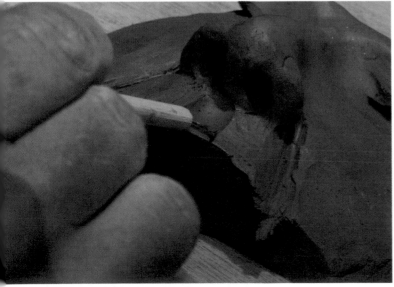

Add the philtrum under the nose.

2. Don't make the bottom of the nose too flat.

3. Don't make the angle between the lip and the nose too sharp.

At the bottom of the nose cut off the corners like this.

4. Don't make the nostrils too large.

Make two balls the same size and add them to the sides. These represent the two pieces of cartilage that are in the nose. Blend them in.

To make a better nose, we add some major planes. Start with the background and basic set-up of brow ridge and nose cone as before.

Outside of those we add our nostril wings.

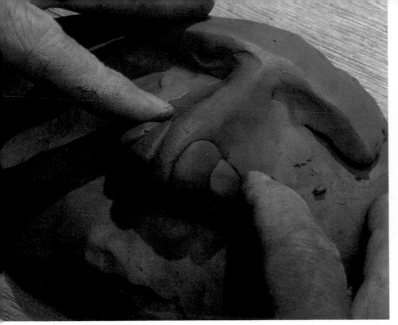

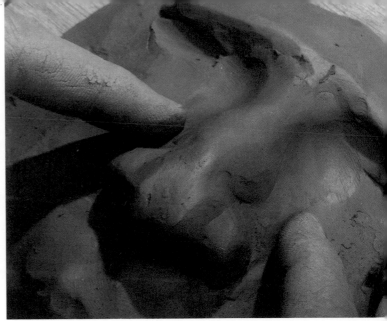

Blend the parts together, adding some material beside the nose, if necessary, to help it blend into the cheeks.

In this middle section it becomes thicker.

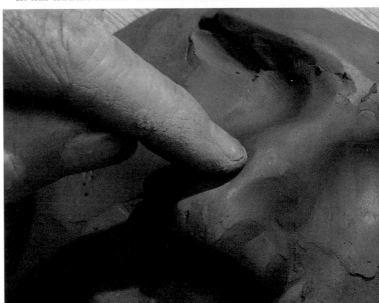

You can see the influence of this structure in the rounded end of the nose.

Then it blends in toward the tip of the nose.

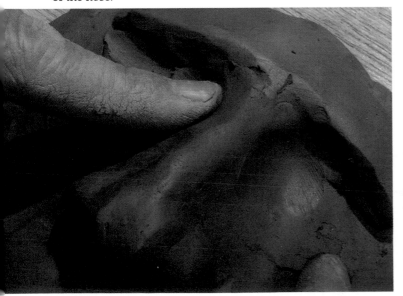

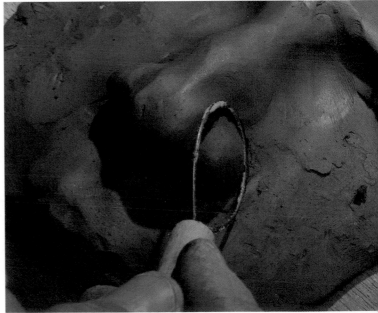

At the bridge of the nose, you shape it so you can see the effect of the underlying bony structure.

The curve of the cheek starts here above the nostril...

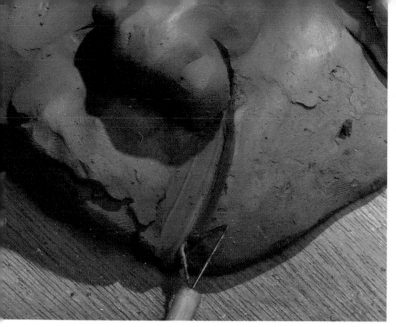

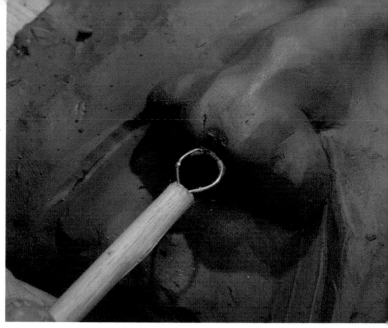

and comes down the side of the mouth. Do the same on the other side.

Some noses have an indentation on the tip of the nose cause by the two pieces of cartilage coming together. This is different on everybody so look carefully at your model.

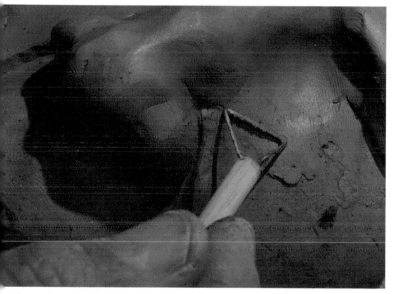

Where the cheek begins there is often a little crease on the nose. If it isn't present in the photo or person you are using as a model, you need to ask yourself how the nose and the cheek come together.

Lift the wings of the nose.

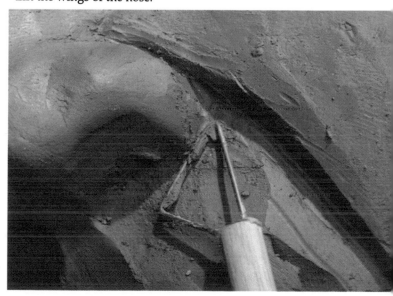

Blend it in for this effect.

The back edge of the nostril creates a fairly distinct line against the cheek. It is one of the very few places on the face where you would use a straight cut.

Look to see how the bottom of the nose connects with the upper lip. It could look like this...

or this...

or this.

Add the hole and curve the lower edge of the nostril.

Here you can see it from the side.

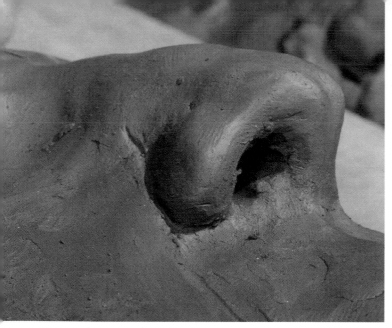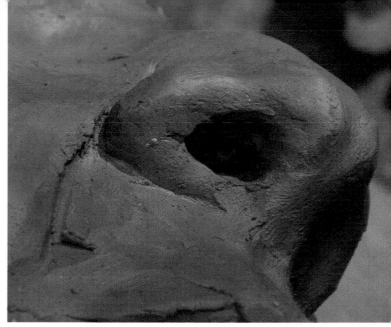

The attachment at the side of the nose is different for everyone. Here are two extremes. This nostril is quite detached.

Here the nostril is attached and comes around the back.

Different views.

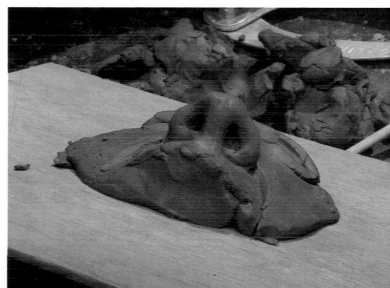

The new nose has much more character and detail than our first effort.

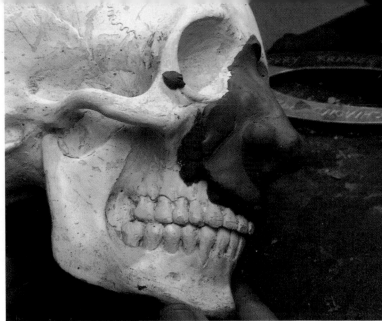

You get a good idea from this how the nose relates to the bone structure of the skull.

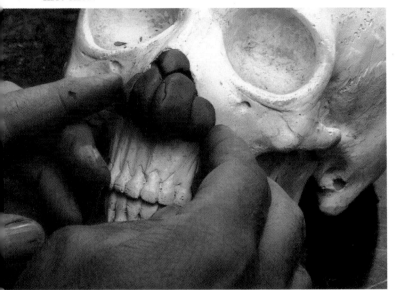

I thought it might be fun to build a nose right on a skull. I begin with the basic structures of the nose.

Return to the face. Lift the corners of the nose.

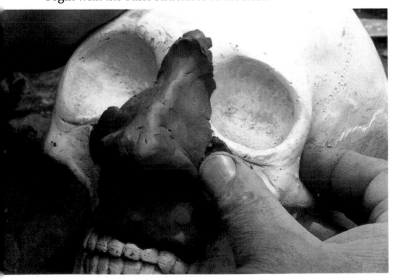

Add the skin on and around the nose. Actually this whole area makes up the nose, with its muscle structure and the combined image it creates for the observer.

Cut away from the edge of the nostril.

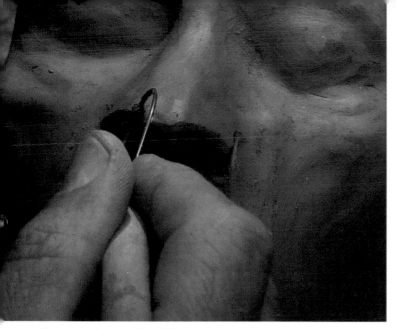

Shape the lower edge of the nose.

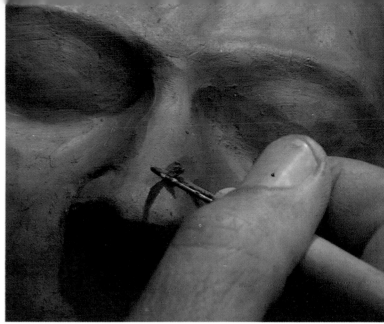

Establish the front plane of the nose.

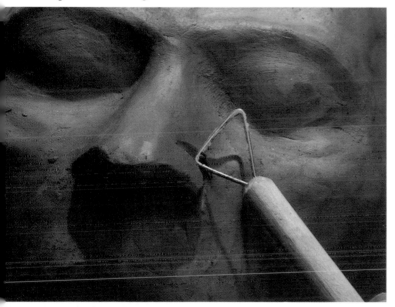

Bring the line of the nostril over the top and soften it.

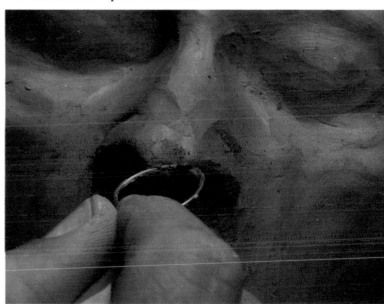

Take away a little of the tip to show the separation between the two cartilages.

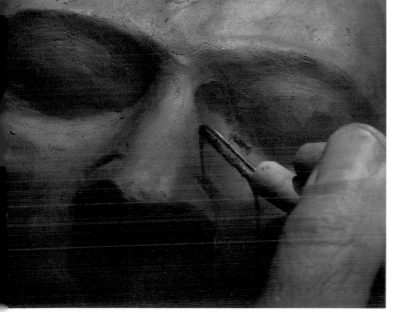

Narrow the plane of the nose, starting at the bridge.

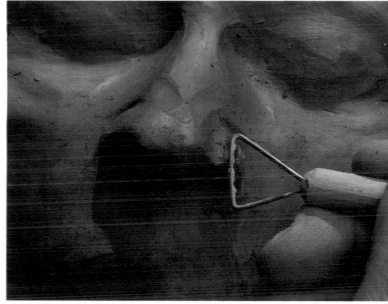

Narrow the front edge of the nostril, bringing out the wings.

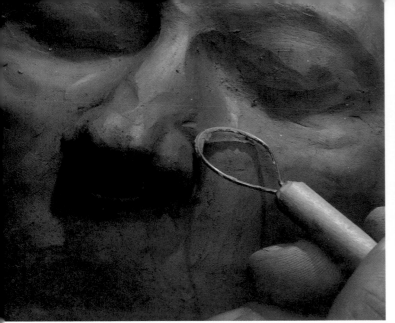

Put in the little angle, above the nostril, that sometimes shows up on faces.

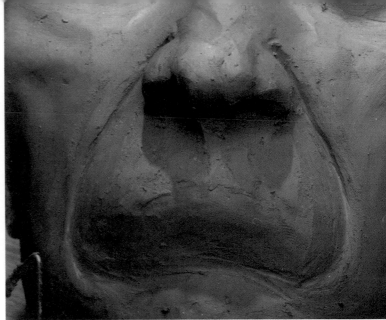

Completed. This helps define the mass of mouth area.

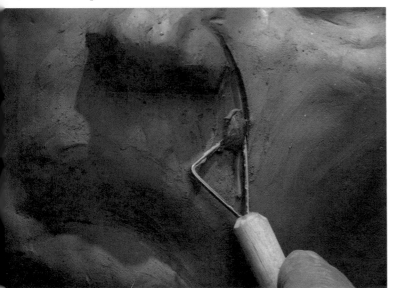

Start at the back corner of the nostril...

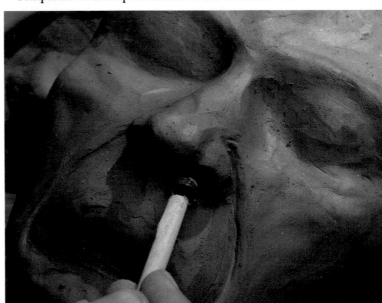

Cut the nostrils.

and establish a plane down, around the mouth, and in, over the chin.

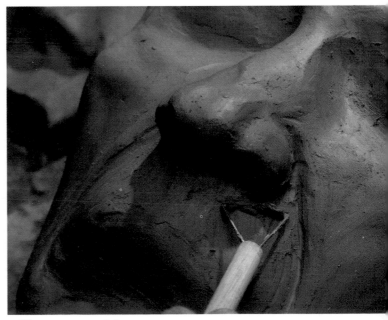

Clean up around the nose.

Flatten a ball of clay to create a rounded platform to practice the modeling of the mouth.

Reshape the ridge into a "Cupid's bow" shape.

The upper lip is made up of three lobes, a round one in the center and a cone at each side.

Cut out the philtrum.

Blend the upper edge into the face.

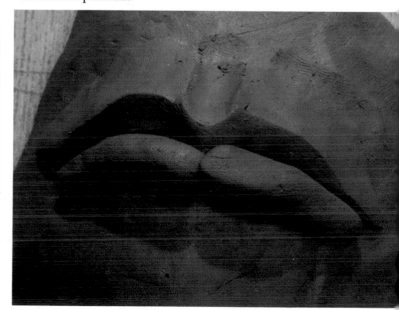

The bottom lip has two lobes represented by two cones of clay.

Blend their lower edge into the face.

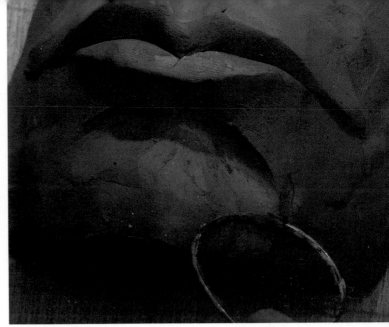

Shape the area between the bottom lip and the chin.

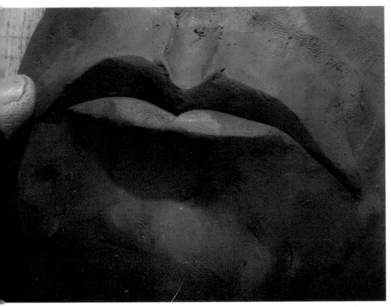

The corners of the bottom lip go under the top lip.

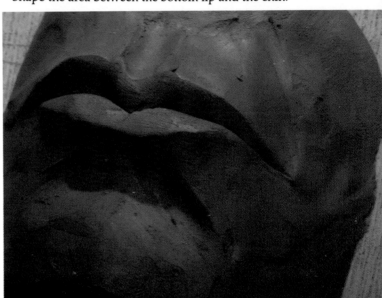

You can also contour the corner above the upper lip...

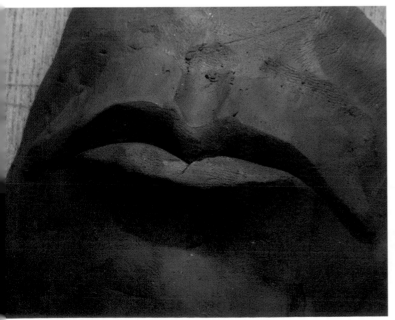

The result.

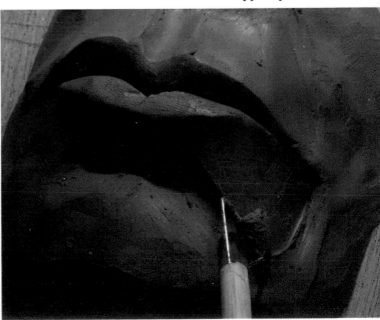

and the corner below the bottom lip.

From the side you can see the roundness that makes realistic lips. The bottom lip usually doesn't protrude as much as the top.

Begin with a single line across.

In carving you need to begin with the area of the mouth raised.

Make a cut along the underside of the upper lip that comes in from the outside, raises up and drops down at the middle.

This is the area as seen from the bottom.

Continue from the middle and make a mirror cut to the other corner.

Come across the surface of the bottom lip, dropping down in the middle...

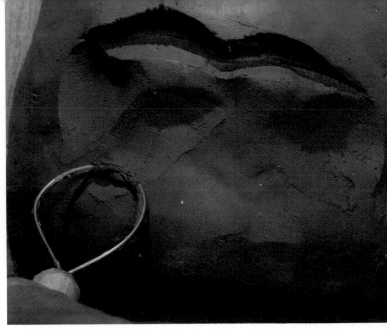

Cut away under the bottom lip toward the chin like this. Do the same in the other direction.

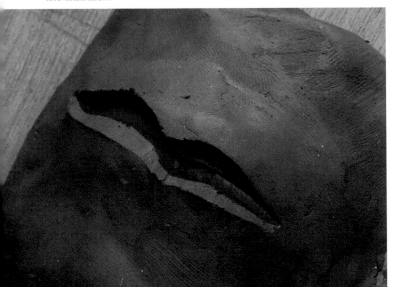

and back up to the other side for this result.

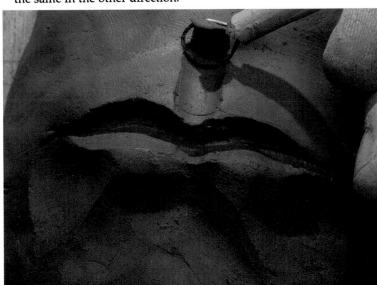

Cut in the philtrum.

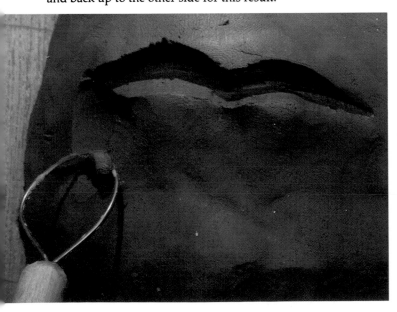

Cut away the end of the bottom lip so it goes under the upper lip.

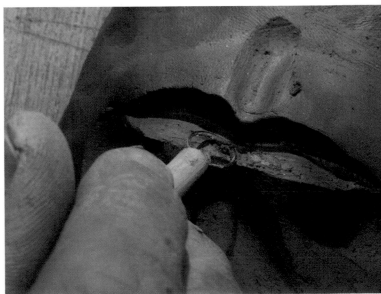

Sharpen the lower lip line. This also helps raise the inside to give contour to the mouth.

Do the same on the top.

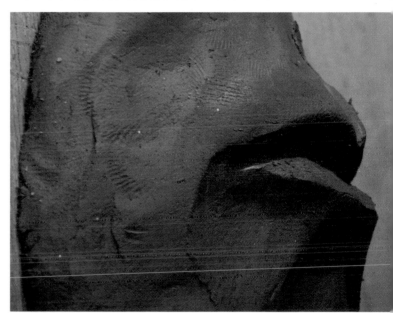

Following the line of the upper lip, cut a deep line between the lips. This defines the opening of the mouth.

The result.

Slightly enlarge the corner of the mouth.

Just a few minor changes, like raising the upper lips or bringing in the edges of the lower lip make dramatic differences.

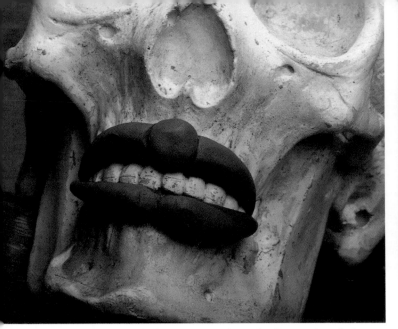

Returning to the skull you can see how the lips are in relation to the bone structure.

Returning to the face, mark halfway between the nose and chin.

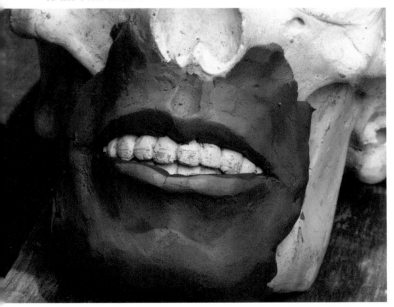

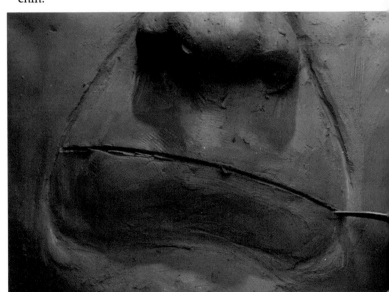

Draw the line of the mouth.

The result.

The corners of the mouth are pretty much directly below the center of the eyes.

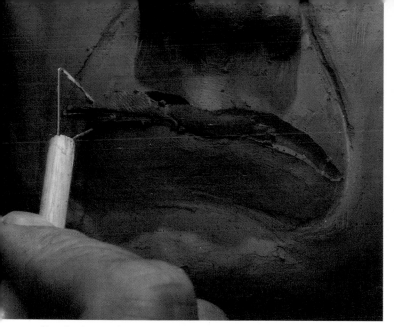

Cut the bow of the upper lip.

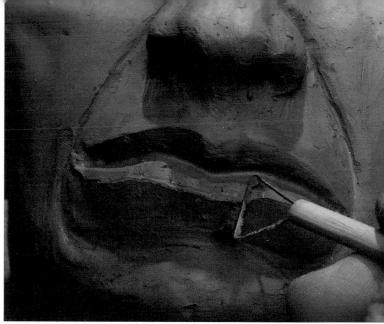

Do the same on the bottom lip.

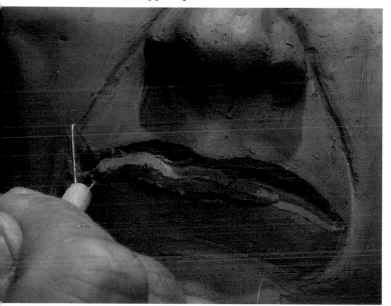

Cut the upper surface of the lower lip, dropping down in the middle.

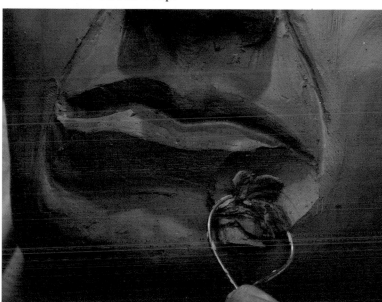

Cut away at the sides of the lower lip to tuck it under the upper lip.

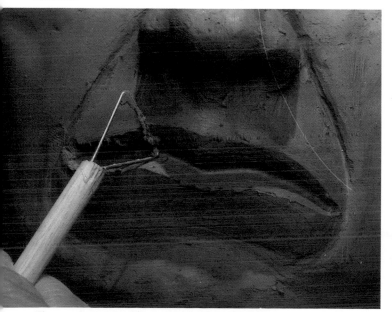

Flatten the upper lip, widening it as you do.

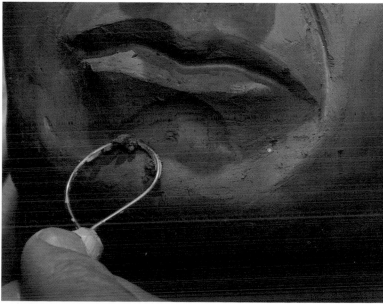

Hollow an arc below the center of the lip.

Carve the philtrum.

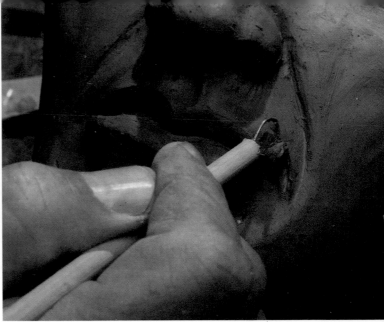

and a cut on the upper lip at the corner like this.

Make a separation cut between the lips.

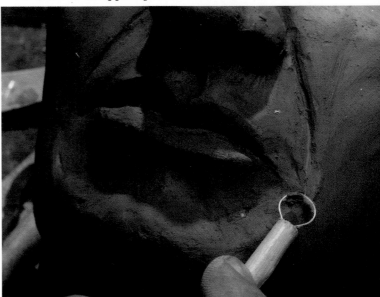

Smooth it up.

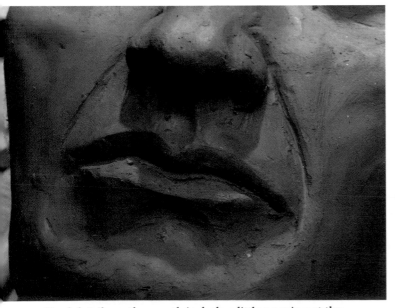

Final details on the mouth include a little opening at the corner of the mouth...

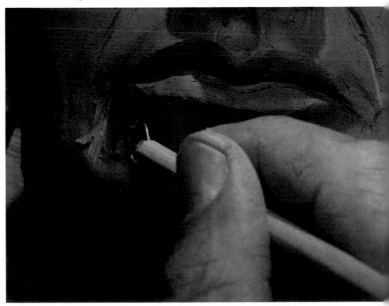

There is also a contour running down the chin from the corner of the mouth.

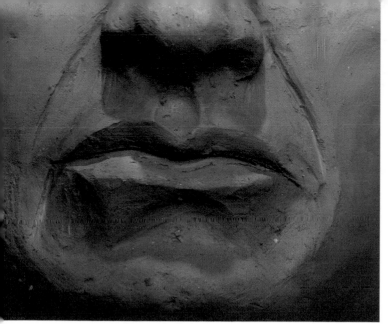

Progress.

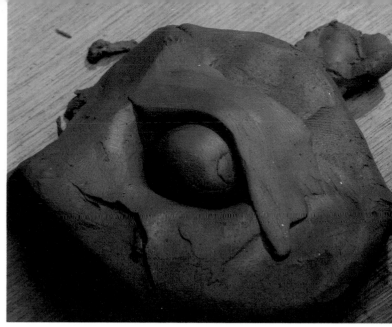

This is blended and made to arc around the eyeball.

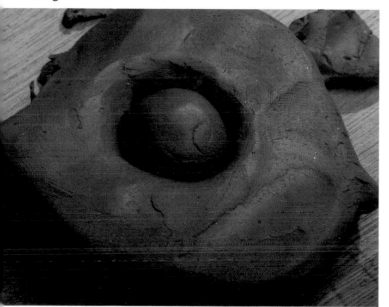

The basic structure of the eye is a ball in a socket.

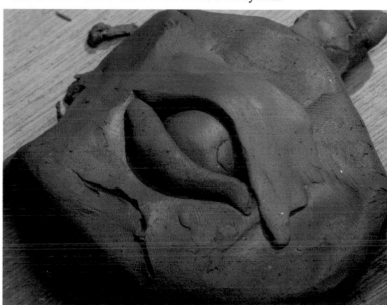

The lower lid goes over the bottom of the eyeball.

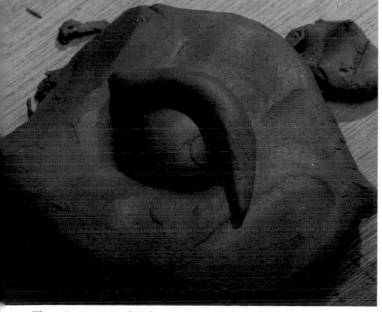

There is an upper lid that goes around the ball.

Blend the lower lid. The corners go under the upper lid, and the contour should reflect the roundness of the eyeball.

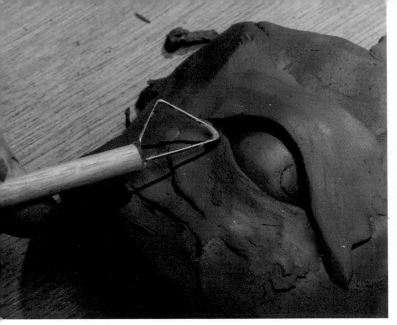

On the inside corner the line of the lower lid rises a little for the tear duct.

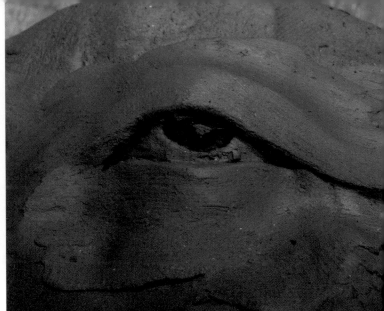

When the eye is more closed you can carve away the iris and leave just a small spot for the light reflection. When you get a chance, go and look at the work of sculptors, see how they dealt with eyes, and decide what technique feels best to you. Real life will not help you at this point.

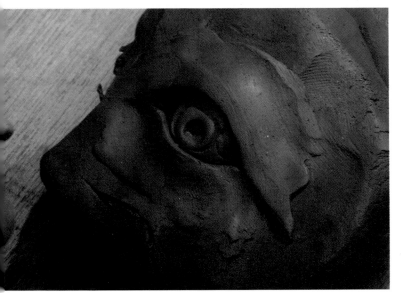

For the sculptor/carver eyes present a challenge. They are such smooth parts of the face that the light does not play on them in the same way it does the other features. In addition, the iris and pupil are features that are beneath a transparent cornea, so you can't carve them realistically and need to find a way to represent them. On an open eye you can draw the outline of the iris and depress the pupil. The circles have to be round or the eye won't work.

Another way is to leave a sculpted tab coming into the area of the iris. The little tab serves the same purpose as the white glint the painter puts in the eyes of his subjects. It acts to reflect light and give the eye life. It is not the pupil.

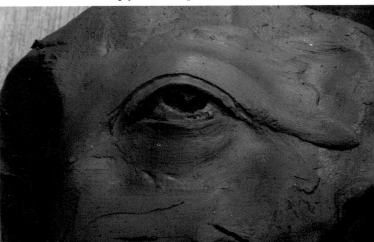

Add a line in the upper lid.

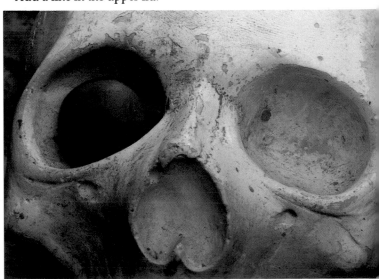

With the skull you can see how the eye structure works. I'll put an eyeball in the socket. Sometimes it helps if you let the eyeball harden a little, so it won't be distorted as you add the skin to the front.

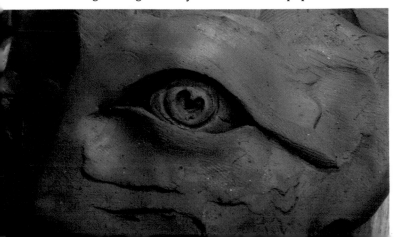

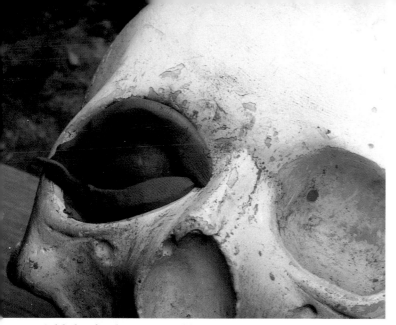

Add clay for the upper and lower lids.

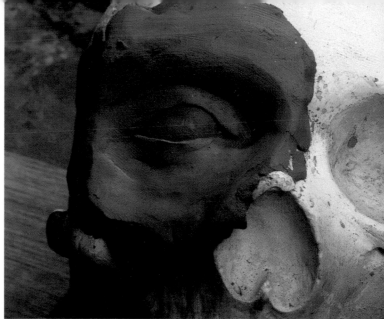

Add the cheek area and blend.

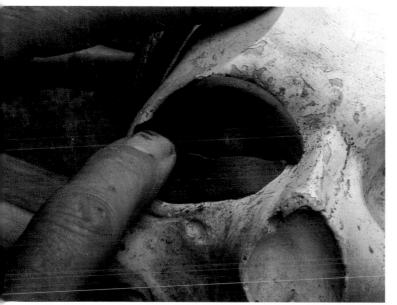

Blend it with your finger.

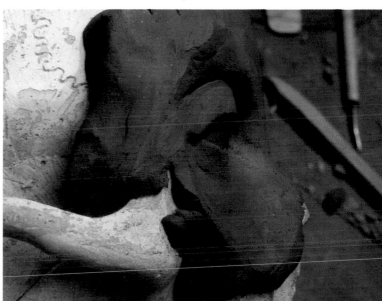

From the side you can see that the top lid is further out than the bottom and that the front of eyeball is not straight up and down, but slants inward at the bottom.

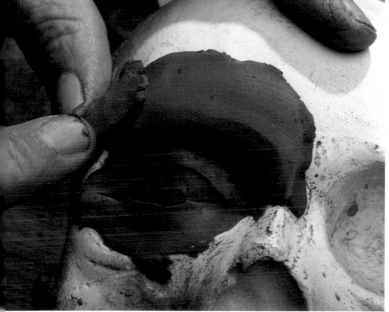

Build up the brow.

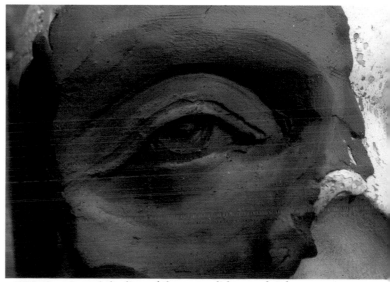

With the iris and the line of the upper lid carved, it becomes quite effective.

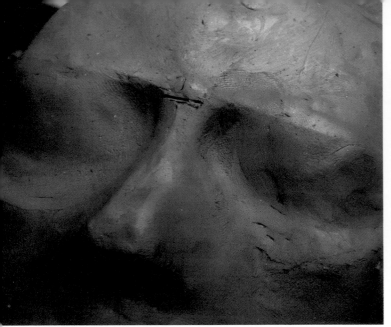

Returning to our form we can apply what we've practiced. Prepare the areas around the eyes so they are both same size and shape.

The other extreme has the eye very exposed. The brow arches high.

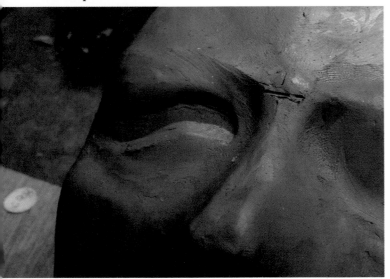

There are two extremes of eyes. One has a brow that overhangs it heavily.

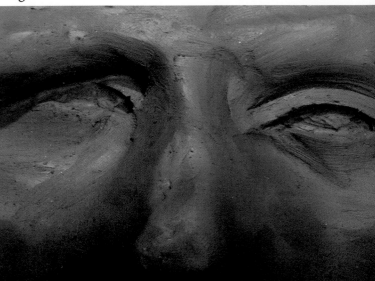

Here you can see the difference. The eye in the heavy brow is barely visible, being hidden in the shadow. On the arched side, the eye is largely visible.

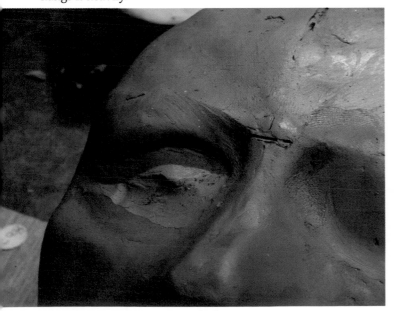

The eye is largely hidden by the brow.

Reshape the eye mounds and mark one fifth width of face.

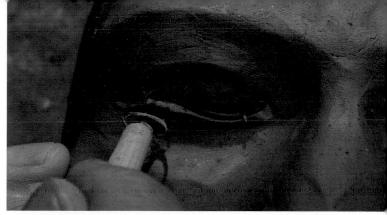

Draw a line across each eye. This will help you see the contour of the eye. Adjust so they are the same.

Round off the eyeball.

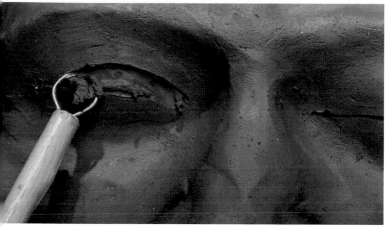

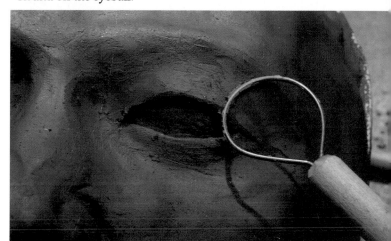

Cut the arc of the upper lid.

Shape the contour of the lid so it follows the ball shape.

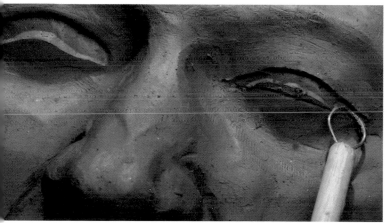

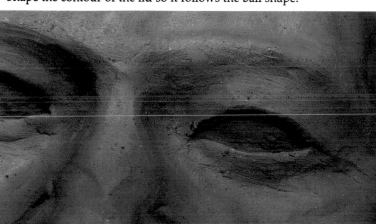

match the line on the other side. Start smaller to establish the line and work your way up. Continue to raise the arcs until they are where you want them.

Progress.

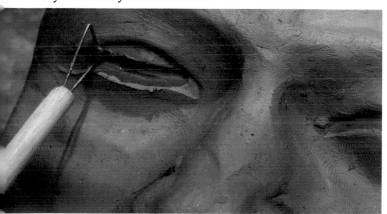

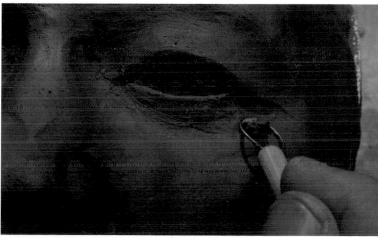

Establish the bottom line. It may help to turn the piece upside down to get the shadows working for you.

Take away from the lower lid to give it contour and tuck it under the upper at the corners

69

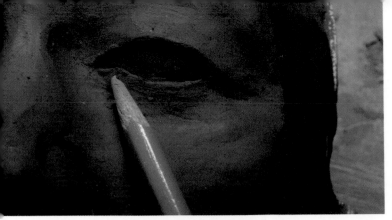

Add the slightly raised area of the tear duct.

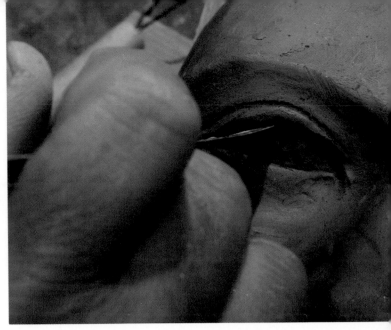

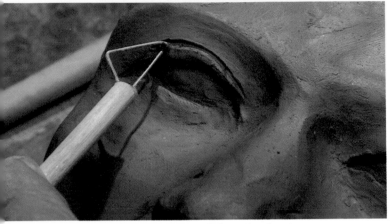

Add a crease for the upper eyelids and soften it.

and two arms from the top of the v which will be stop cuts.

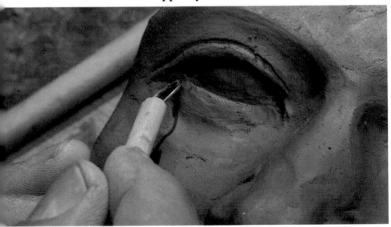

Decide the kind of contour you will have under the eyes, and begin to shape it.

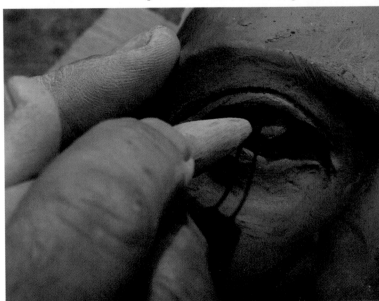

Push a loop into one of the arms and rotate around to the other. Repeat on the other eye.

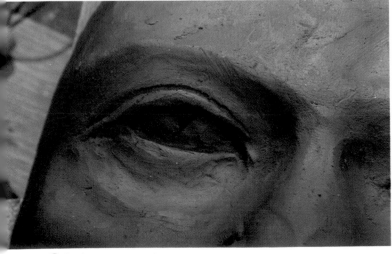

Cut a v...

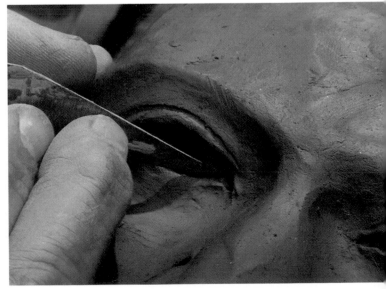

Come back and make adjustments to the roundness of the eyeball.

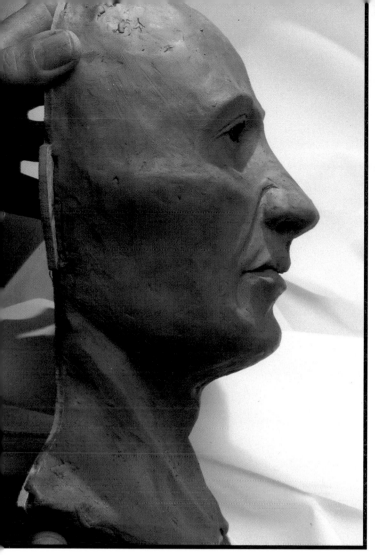

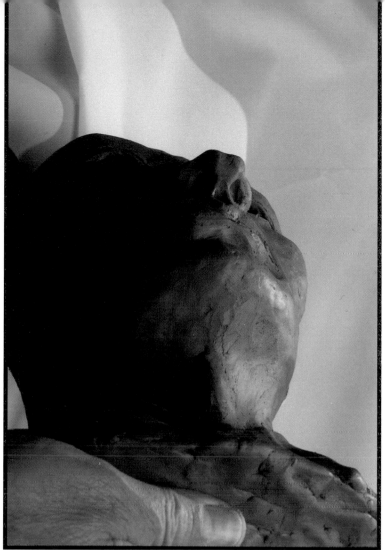

It is helpful to look at the figure from every possible angle with the light creating different shadows. This will help you see the figure in a new way and will greatly improve your carving.

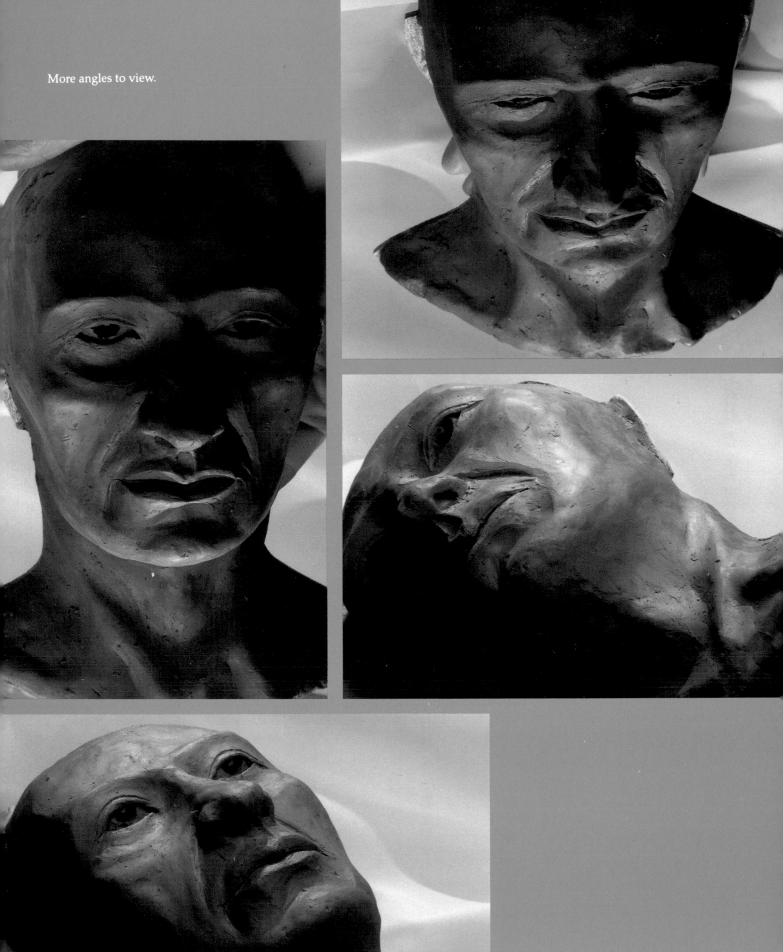

More angles to view.

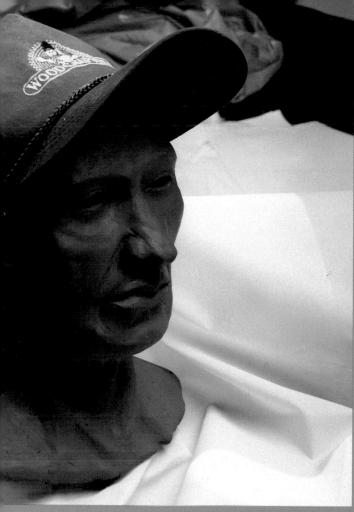

It is also useful to place a hat on the figure and see what effect it has.

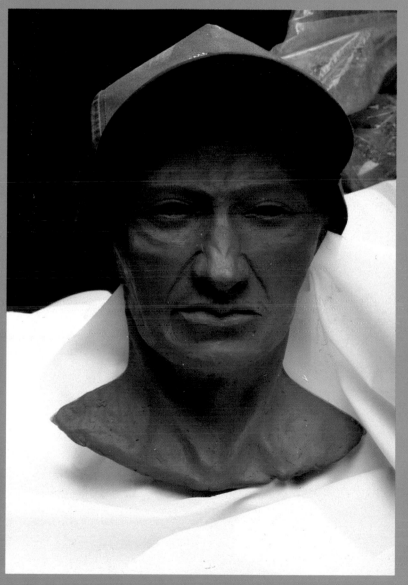

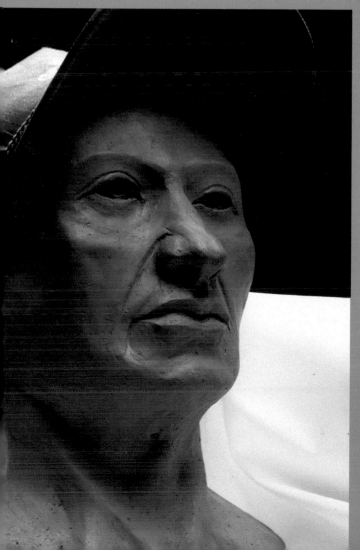

If you wish to save your clay work you need to remove it from the template after it dries to leathery hardness. If it dries completely on the template it will shrink and crack. Free the clay face from the template by removing the screws and slicing around the edge with a knife.

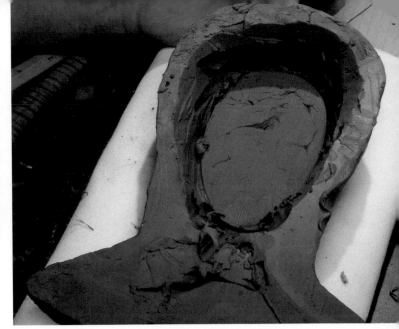

Removing the core will help the drying process.

Gently pry it off...

and cut a half inch channel around the core, going down to its forward edge. Go deep enough so you don't have to use a lot of force to pry the core out.

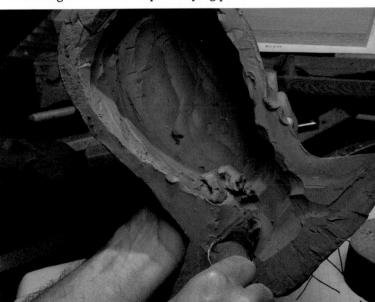

To promote drying even more, I reduce the thickness of the walls to about 3/4". I hold it in my hand to help judge the depth, so I don't cut through the front.

Soften the edge to make it less fragile.

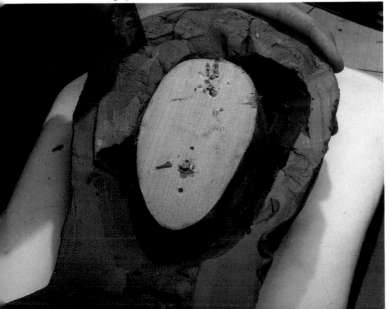

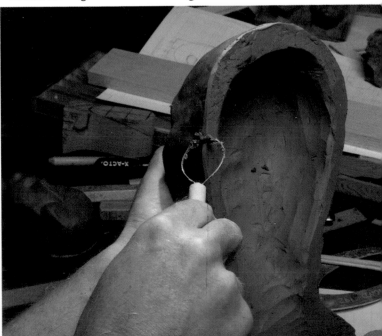

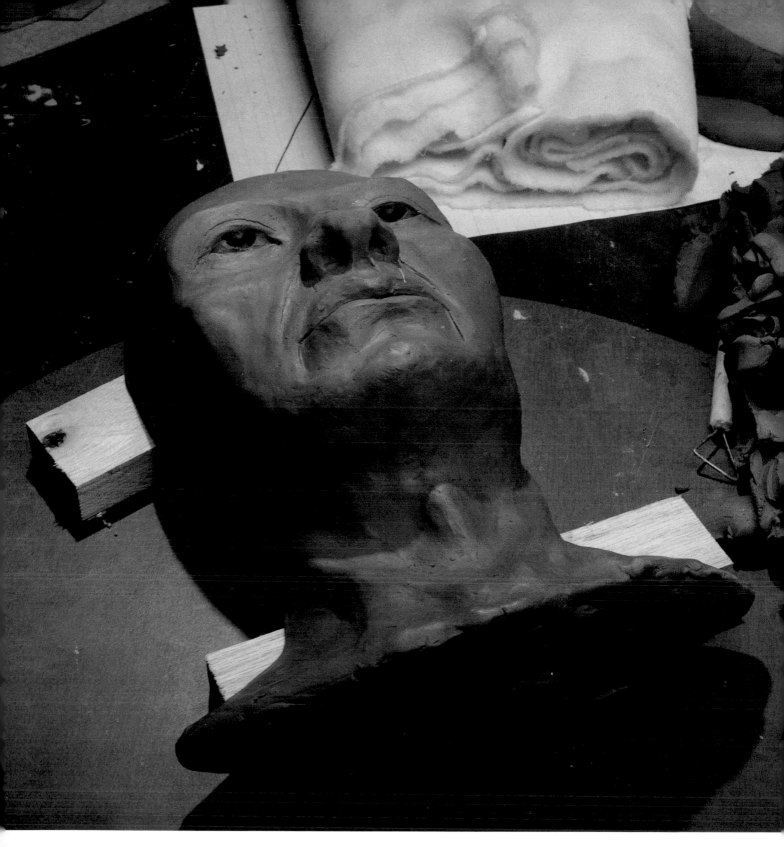

Support the head in a way that lets air flow underneath, and put in a place where it can dry slowly. Leave it like this for a couple weeks and it will be completely dry. It can be handled then, but it is still fragile. You could fire it in a kiln and it would become a hard terra cotta mask.

Exercise 6

Carving in Wood

Finally we come to wood. In this practice exercise you will learn to apply the lessons of the clay to carving in wood. This is where all of this has been leading. The planes stay the same as does the basic approach to carving.

Begin with a blank cut to the dimensions in the beginning of the book. The depth is the same as we used on the other exercises: from the front of the ear forward. Mark the major sections of the face.

The result.

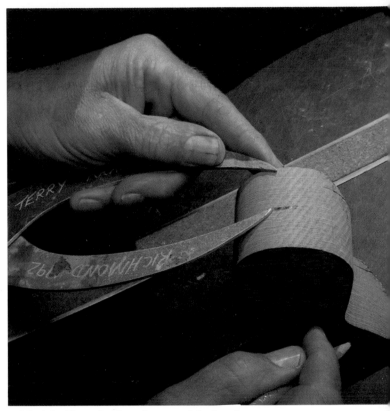

Mark halfway back at the top of the head.

Mark halfway back at the neck, under the jaw. Mark the area to be removed.

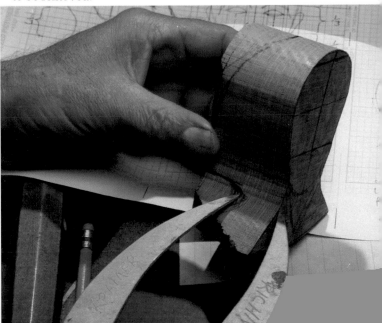

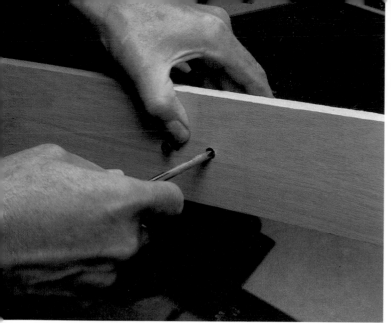

Attach the blank to a board. This gives you something to hold onto, and allows you to clamp it in a vise or to the table.

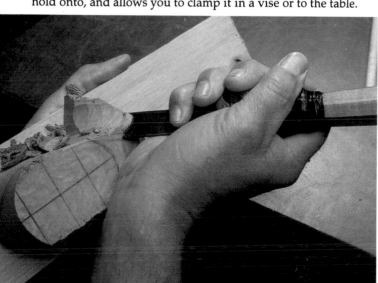

Using the tool like this is fast and accurate. You get the strength of your wrist and a nice paring motion. Take the neck down to the rough shape.

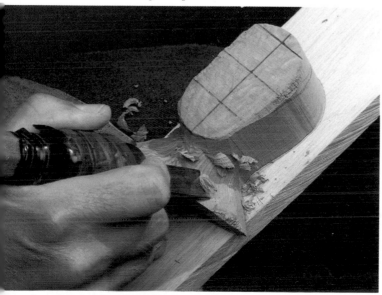

I push too, when it works to my advantage.

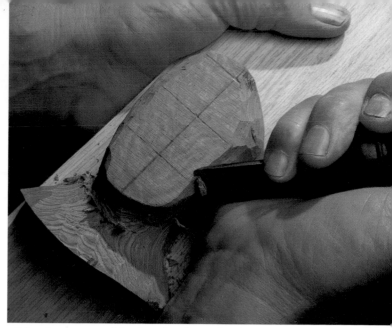

Trim the corners of the face, but leave the chin square for now.

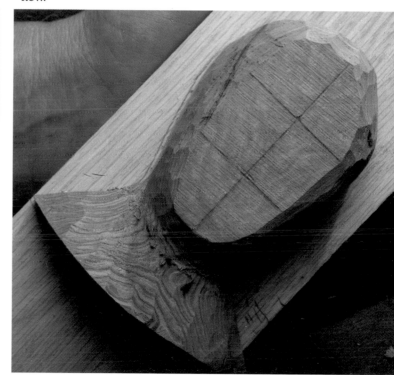

This takes you to the point that is the same as the starting point with the clay.

Draw a line from the nose to a point 2/3 of the way from the front edge at the top of the head on both sides.

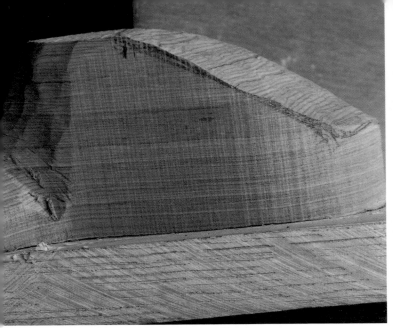

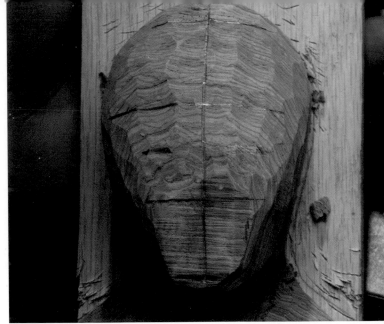

Cut a plane that follows that line. It is important to get enough depth on this line or the whole piece will appear flat.

Redraw the reference lines, and mark the lower line of the eye socket, about halfway between the brow and nose lines.

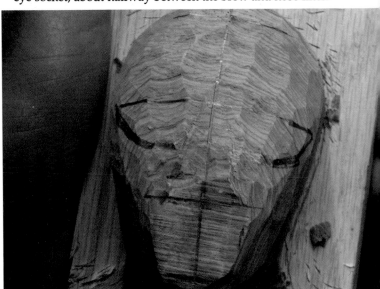

Round off the edge of the plane, just slightly.

Draw the nose so its base is about a third of the width of the face at the nose line and 1/2 the width of the bottom of the nose at the brow line. This will vary from face to face so use your eye and calipers if you need to change. Then draw the line of the eye sockets from the top corner of the nose, to the halfway mark, and around to the side.

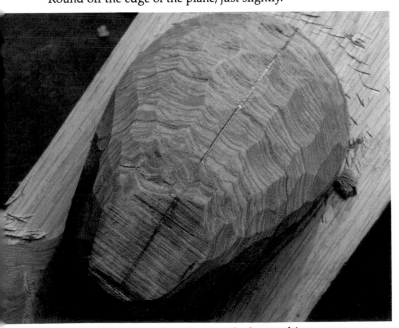

Round off the lower face, leaving the lower chin square.

Carve the planes of the forehead, out from the center and up. It is important to have a single source light to be able to see this.

Carve the temporal plane.

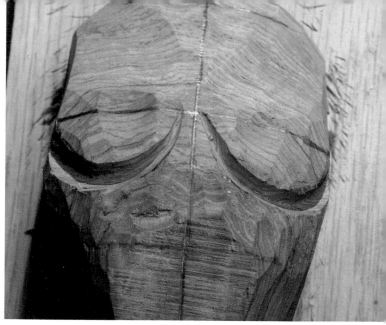

Progress.

Progress. The planes are a bit exaggerated for the camera, but in carving it is better to exaggerate than to underemphasize at first. As you do more faces you will adjust.

From the nose base line, cut back on the cheek plane.

Follow the line of the eye socket with a v-gouge. This creates a stop cut.

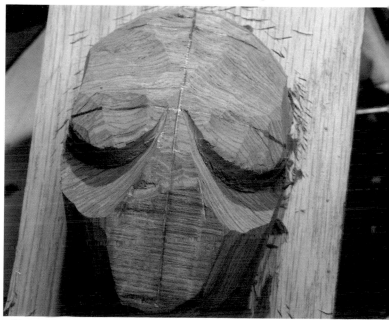

Progress.

Start at the middle of the side of the nose...

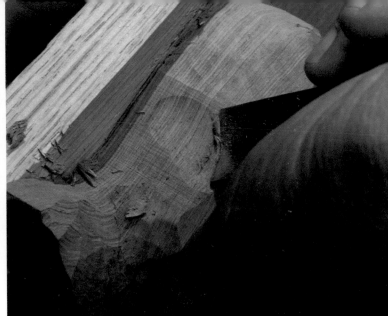

Start here and carry the side of the cheek plane back to the ear line.

and carry the plane that goes beside the mouth and back along the jaw line. Widen the plane along the cheek plane.

Progress.

Gouge under the jaw line to make it more distinct.

Lay in the groundwork for the muscles of the neck.

Bring out the line of the cheek bone, which goes straight back.

This brings things to the roundness of the jaw line.

Progress. Repeat on the other side.

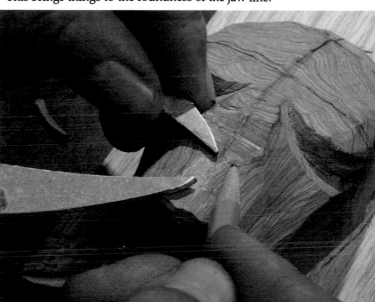

Mark the lower section of the face in thirds.

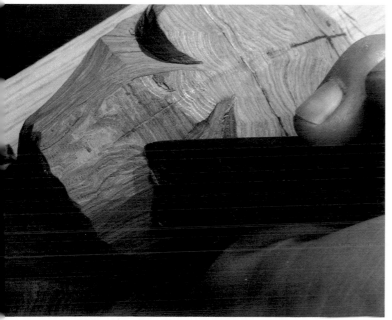

Round off the mouth area, but not too much.

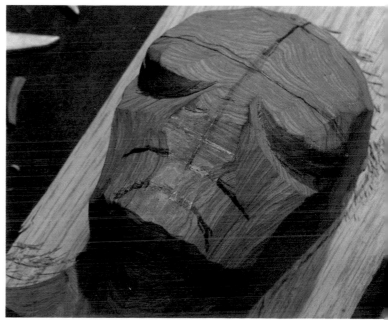

Draw in the mouth and chin lines.

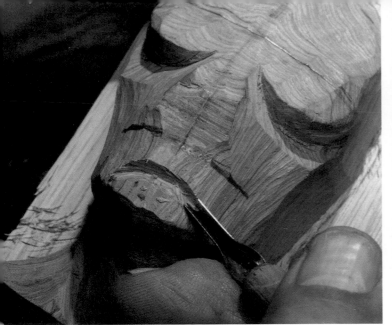

Come over the chin line with the gouge. You are just starting the cut, so don't go too deep

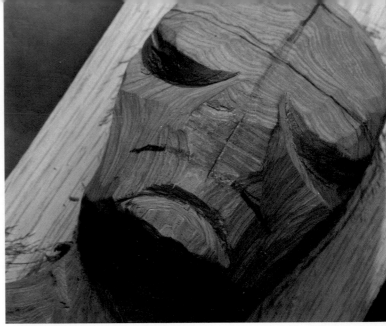

to create a nice v-shaped channel.

Cut back to the line from the chin with a larger gouge, keeping the cup against the work.

Cut from the mouth line back to the chin channel.

Come back to it from above...

Cut in below the nose, with the cup of the gouge away from the nose...

82

and come back to it from the mouth.

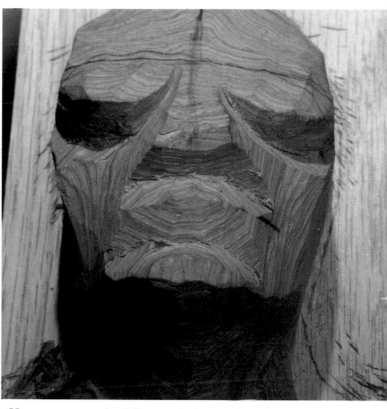

Here you can see the difference, before on the right and after on the left.

The result.

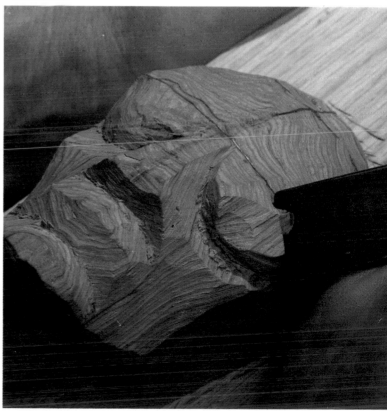

Starting at the brow line, round over the eye areas.

Deepen the plane beside the nose to blend the nose with the cheek.

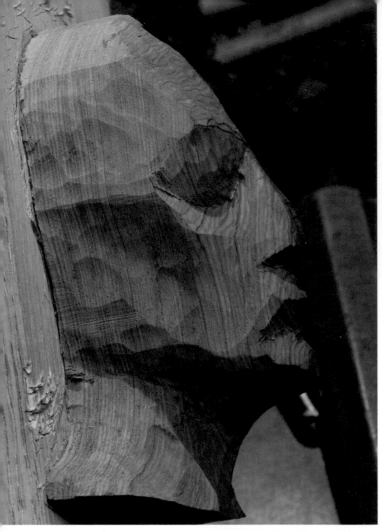

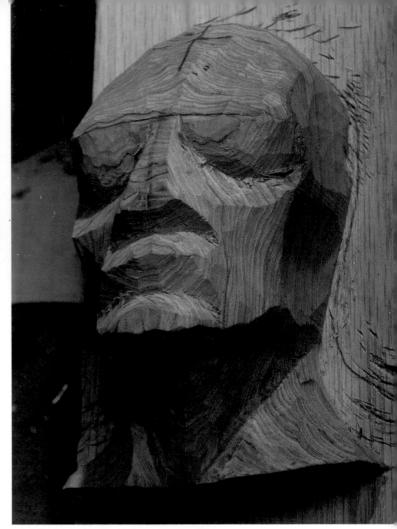

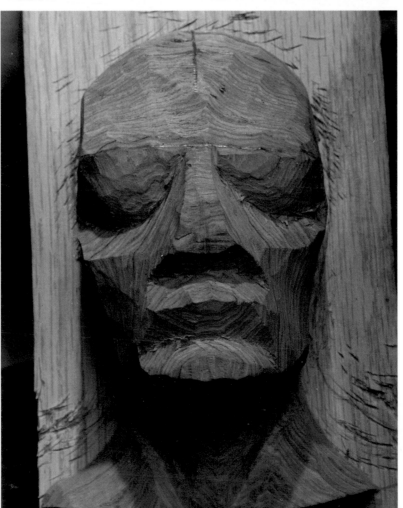

The basic planes are established.

Begin the nose by lifting the corners. You may wish to draw it first.

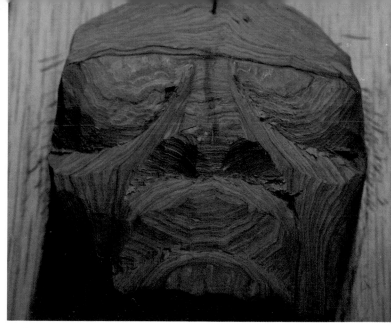

This makes a big difference already. The underside of the nose is now three planes: two triangles flowing up and out, and a squarish area between them.

Cut at an angle toward the lip...

Now I block the nose. Come up beside the nose with the gouge cup away from the work. This helps establish the unbroken flow I want between the nose and the cheek.

then cut back from the lip.

The width of the nose is about 1/5 the width of the head at the widest part. Mark it.

Narrow the nose.

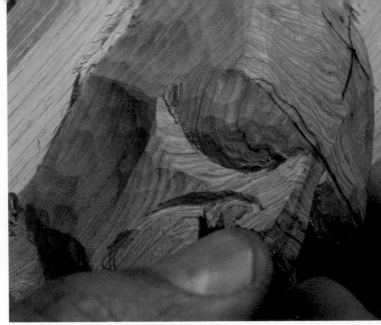

With the gouge round the edge of the nostril.

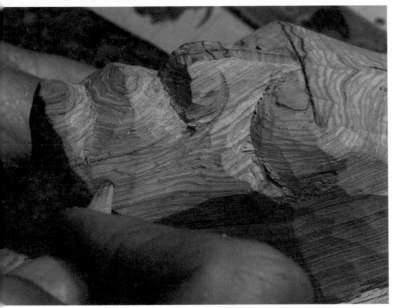

Mark the nostril flares and the line of the crease that runs down the face.

Add the contours of the nose. Begin with the nostril flare.

Starting at about the mouth line, cut up the line with a v-tool.

To shape the bony part of the nose I need to deepen the inside corner of the eye.

Shape the side of the nose.

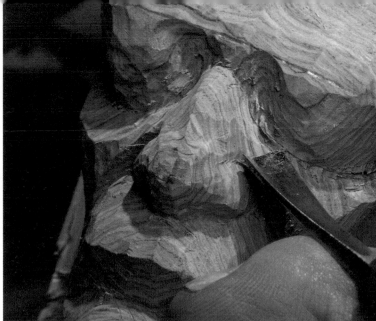

As the nose is shaped, blend it into the cheek. The nose needs to be seen as an extension of the cheek.

Contour the nose at the brow ridge.

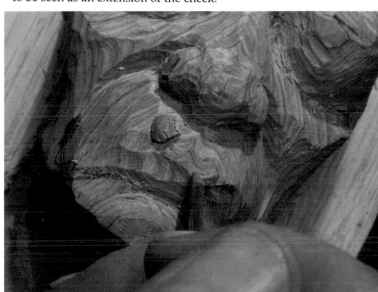

Reduce the overall mouth area, to prepare it for carving.

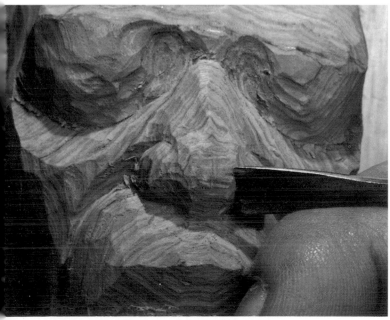

Carve up the ball shape at the end of the nose.

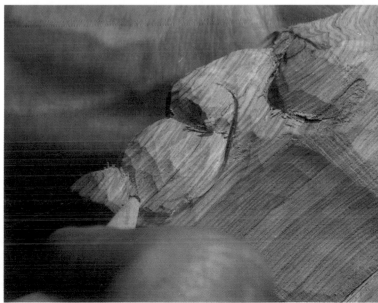

Redraw the internal facial plane that comes down the cheek and over the chin.

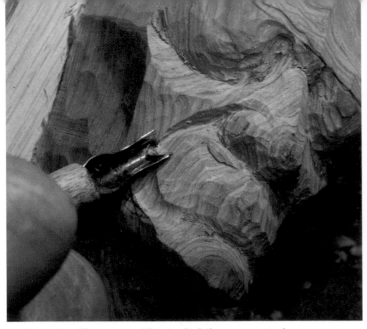

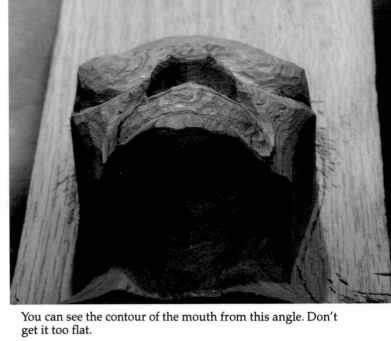

Carve it with a gouge. This is slightly exaggerated so you can see it in the photo.

You can see the contour of the mouth from this angle. Don't get it too flat.

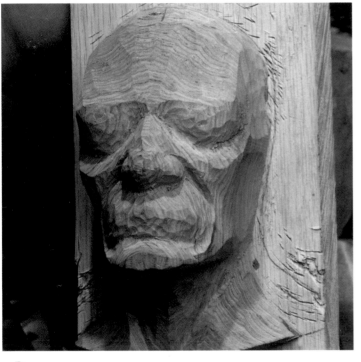

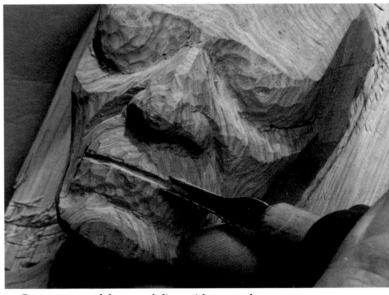

Cut a groove of the mouth line with a v-tool.

Lay the v-tool in the mouth line and angle the blade up to carve the cupid's arrow of the upper lip. As you get to different contours, rotate the blade to change the angle of cut.

Progress.

Draw the lines of the mouth. The mouth line is approximately halfway between the chin and the nose, and its ends should be even with the centers of the eyes.

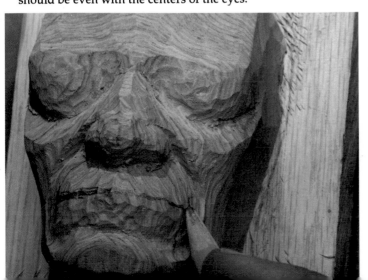

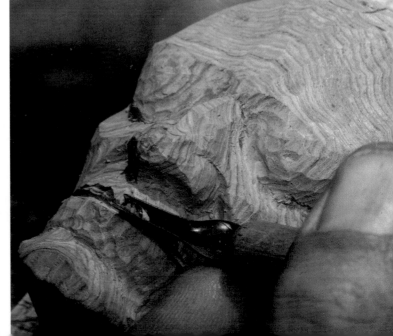

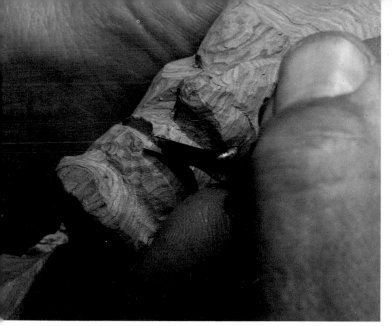

Use the same method to cut the surface of the bottom lip, using the bottom edge of the v-tool to cut. It dips in the center to form the two lobes.

Create the bow shaped hollow under the center of the lower lip.

Widen the lips, top and bottom. By making a series of cuts to widen the lips you give them a natural contour.

Pick up the contour that goes on the line from the nostril to the corner of the upper lip. It starts about half way above the lip.

Hollow out under the outside corners of the mouth and tuck the bottom lip under the upper.

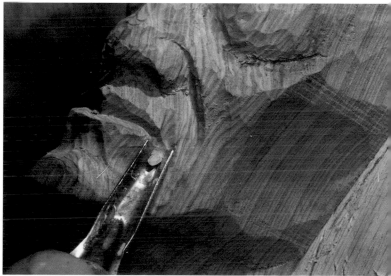

Then do the contour line that runs from the corner of the mouth into the chin.

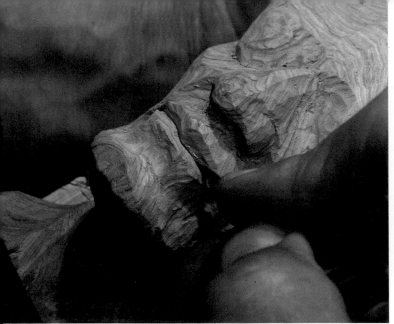

Make a separation cut, hard cut, between the lips. Follow the contour.

With the nose and mouth set I can form the nostrils. Don't make them too big.

Cut back to it along the lower lip to open a space between the lips.

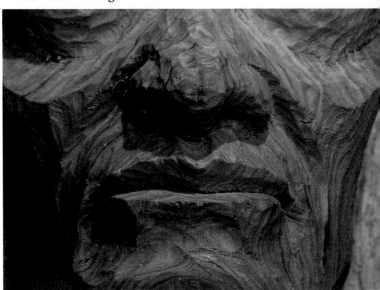

Carve the philtrum to take the mouth and nose to this point.

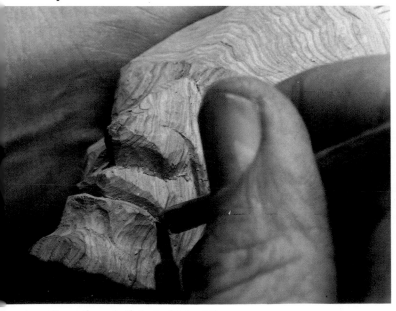

Open the mouth just a little at the corners.

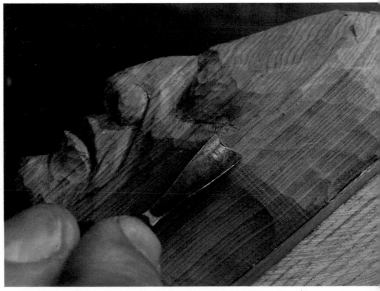

Prepare the area of the eye, carrying the cheek bone into the temporal plane.

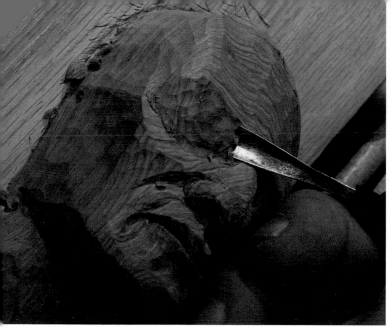

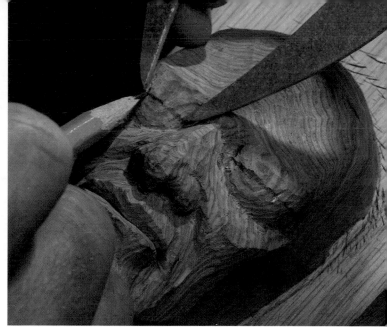

Shape the eye surface under the brow ridge. Before doing this you need to decide the type of eye you will have. We are going to have an average eye, not set too deeply. It's important when you do this that you work from the side. From that perspective you will not see the inside corner. One common mistake is not to make that corner deep enough.

Mark the outer edge of the eye.

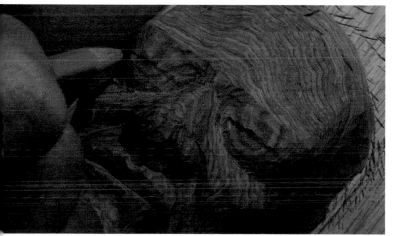

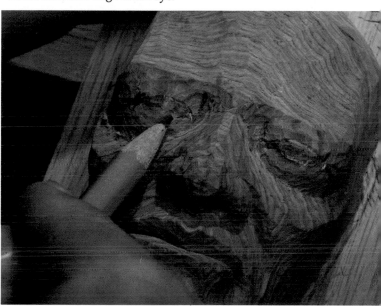

Draw the line of the center of the eye.

Draw in the lines of the eye.

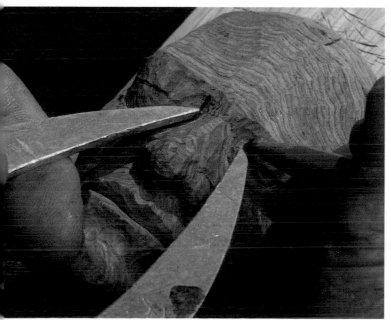

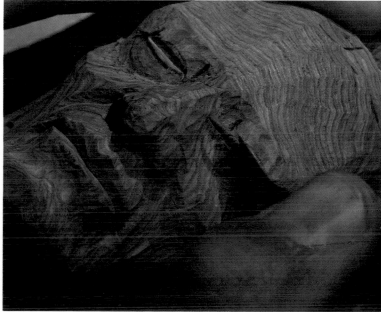

Be sure you have one eye width between the eyes.

Carve the center line with a small v-tool.

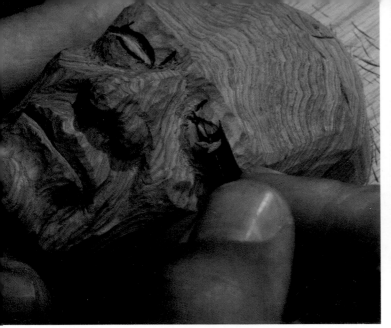

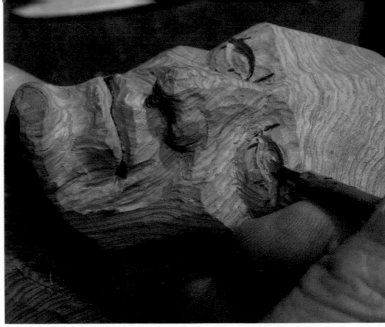

Starting just a little below the outside corner of the eye, trim the upper lid with a v-tool.

Round off the eyeball. I use a micro-skew. Remember the eyeball is further forward at the top than at the bottom. Don't make a hard line between the eyeball and the lid. This makes the eyeball look like it's rattling around in the socket.

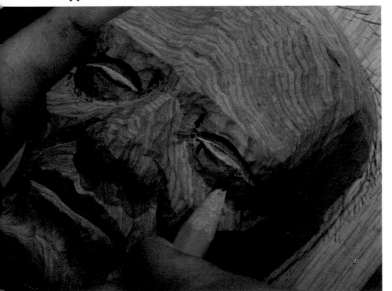

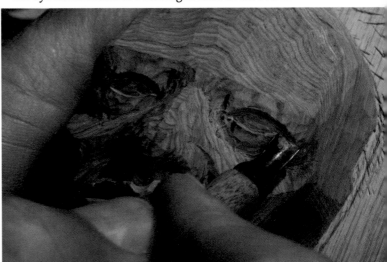

You don't want to take the lower lid to the corners. It is a narrower cut.

Contour the lower lid so it matches the contour of the eyeball. The outside corners of the lower lids tuck under the upper lid.

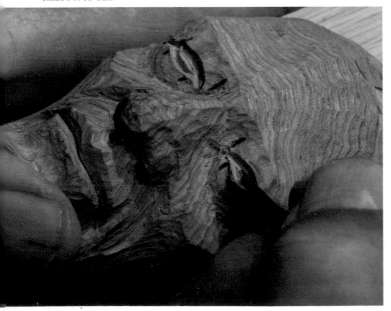

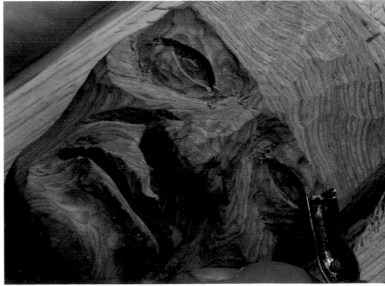

Cut it with the v-tool.

Contour the upper lid in the same way.

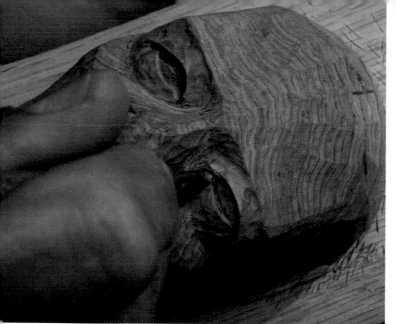

Cut down at the inside corner of the eye, raising the area of the tear duct.

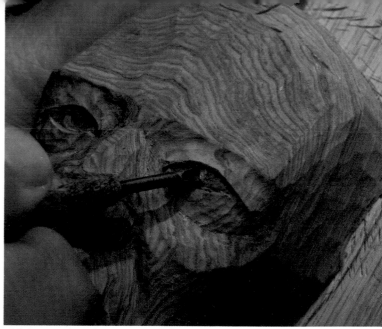

Make a series of cuts around the circumference of the iris, slanted back toward the light spot. These will clean up the iris...

The iris and the light spot are made as they were in clay. Begin with a v-cut. This cut should slant out into the iris.

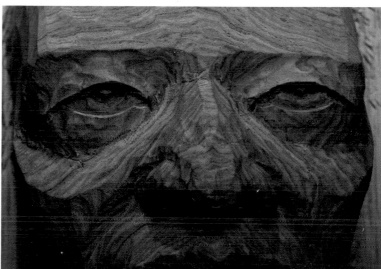

for this result.

Make stop-cut arms at the top.

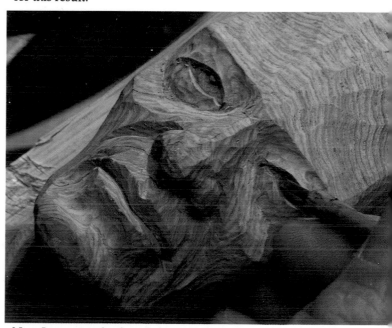

Now I can come back and clean up the contour of the eyeball.

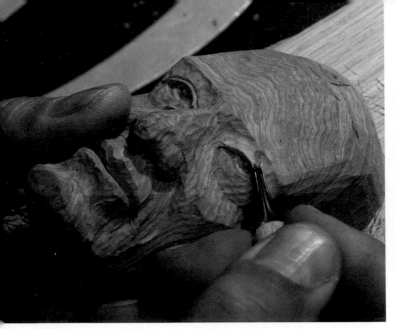

Cut in the fold of the upper eyelid, using a v-tool.

Return to the neck to finish it. Refine the large muscle that goes from the back of the ear to the center of the collar bone.

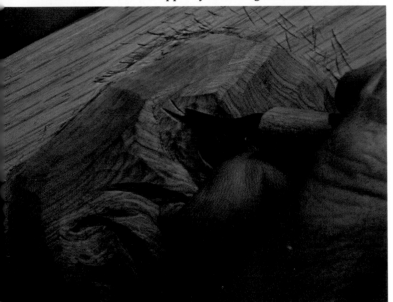

Add some accent lines to the corners of the eyes.

Sand lightly to remove the sharp ridges of the knife cuts. This will help you read your surface and correct any spots that are not correct. Use 250 grit paper or finer.

This area under the chin has a flow from the chin down. A little sanding reveals that the knife cuts break instead of reinforcing that flow.

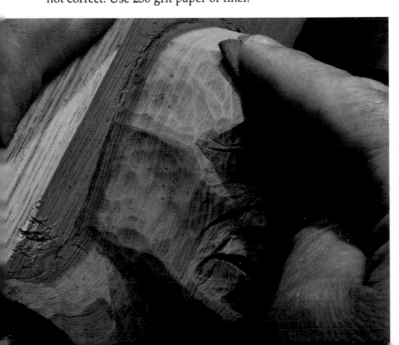

Use the knife to create the flow and add the Adam's apple.

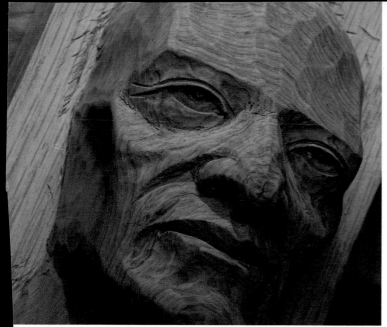

You can add details like a little hollow under the cheek bone in the front, as I did here on the face's right cheek.

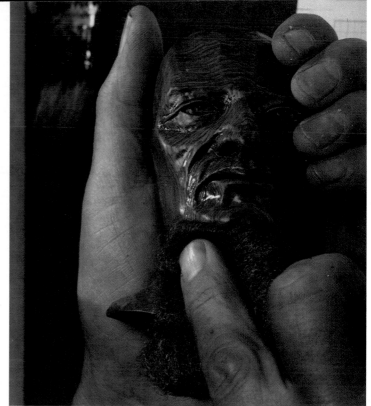

Steel wool after it is dry and put on several other coats. The last rubbing with steel wool should dull surface, but be careful not to go through the finish.

Thin black artist's oil paint just slightly.

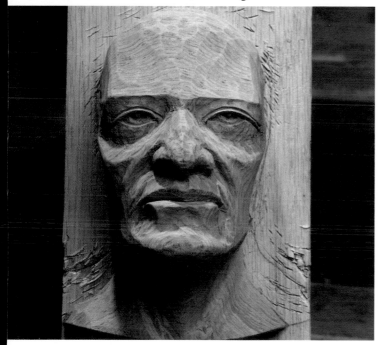

The carving is finished.

The face is carved to show up in the light. The finish we apply will enhance the areas that are in shadow so the piece will be dramatic in any light. Begin with a coat of Deft™ satin finish lacquer.

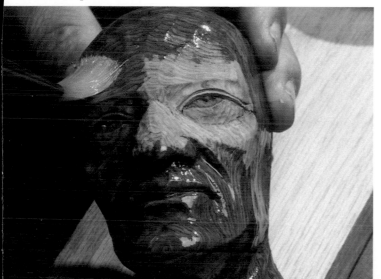

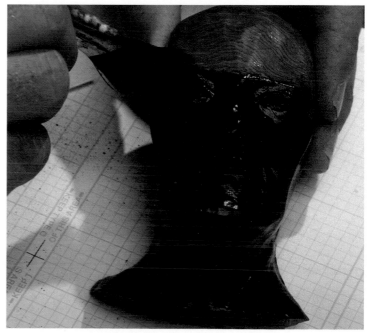

Load the brush and paint the carving black. Get into all the nooks and crannies.

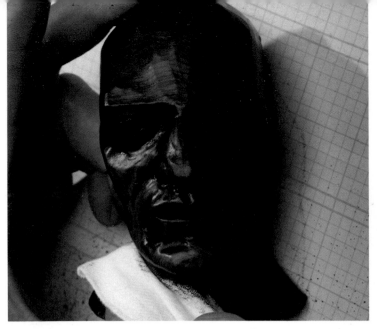

Take a soft cotton cloth, like an old t-shirt, and wipe off the paint. I take away as much of the paint as I can. The lacquer will absorb a certain amount of the stain which gives me the darkening I am after.

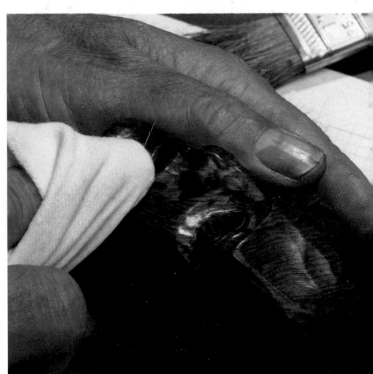

Finally with the cloth wrapped tightly around your finger, wipe it again. The finger keeps the cloth from going deeply into the crevices.

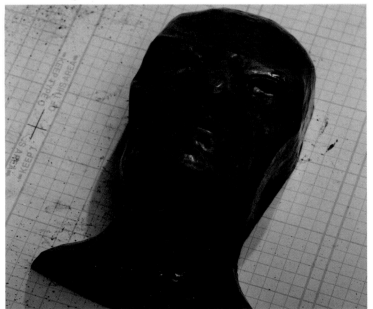

There are still some dark areas that the cloth didn't get to.

Dry brush these areas to soften the finish.

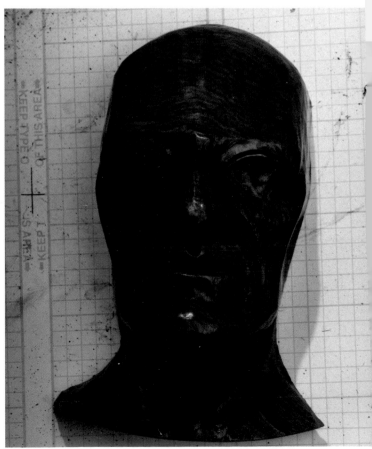

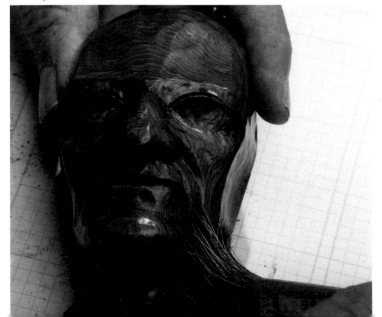

Finished.